IMAGES
of America

NORTHAMPTON
COUNTY

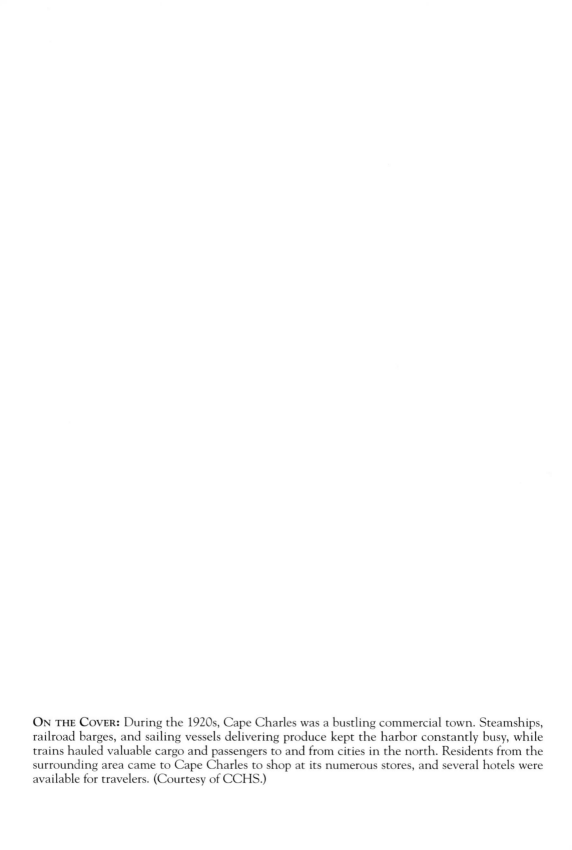

ON THE COVER: During the 1920s, Cape Charles was a bustling commercial town. Steamships, railroad barges, and sailing vessels delivering produce kept the harbor constantly busy, while trains hauled valuable cargo and passengers to and from cities in the north. Residents from the surrounding area came to Cape Charles to shop at its numerous stores, and several hotels were available for travelers. (Courtesy of CCHS.)

IMAGES
of America

NORTHAMPTON
COUNTY

Tom Badger and Curtis Badger

ARCADIA
PUBLISHING

Published by Arcadia Publishing
Charleston, South Carolina

Printed in the United States of America

Library of Congress Control Number: 2010934669

For all general information, please contact Arcadia Publishing:
Telephone 843-853-2070
Fax 843-853-0044
E-mail sales@arcadiapublishing.com
For customer service and orders:
Toll-Free 1-888-313-2665

Visit us on the Internet at www.arcadiapublishing.com

CONTENTS

ACKNOWLEDGMENTS

This volume would not have been possible without the generosity of many people and organizations that shared with us their photograph collections, scrapbooks, and memories of life in Northampton County as it was years ago. The Cape Charles Historical Society (CCHS) has a wonderful collection of photographs, some of which go back to the founding of the town in 1885. Marion Naar and other CCHS members were very helpful and generous and helped arrange additional material from the Mariners' Museum of Newport News and the Hagley Museum of Delaware. The society also has many photographs and documents from the extensive collection of the late Carlisle "Nut" Redden of Cheriton. The Eastern Shore Barrier Island Center (BIC) in Machipongo is a wonderful resource and shared its photographs of life on the barrier islands. Many thanks to Laura Vaughan and Jerry Doughty. The Eastern Shore of Virginia National Wildlife Refuge (ESVANWR) shared photographs of the refuge taken around World War II when the site was known as Fort John Custis and later Cape Charles Air Force Station. Paige Addison of the Chesapeake Bay Bridge-Tunnel (CBB-T) helped us sort through hundreds of photographs of the construction and opening of the bridge-tunnel. Ted Ward was a very popular and prolific photographer in Northampton who operated a studio in Exmore in the 1960s and early 1970s. We thank Ed Beyersdorfer for sharing negatives of Ted Ward's work. Thanks also go to Dave Scanlan of Exmore, who shared his collection of photographs and postcards, and to the town of Exmore and its town manager, Artie Miles. Several of the Exmore photographs were provided to the town by local residents for the town's centennial celebration in the 1980s. Thank you for contributing. We also would like to thank attorney Carl Bundick, a local historian and collector of all things Eastern Shore, and Danny Phillips, a native of Willis Wharf who has collected a wealth of material on that community.

For a more comprehensive review of Northampton's history, we can recommend some books that aided us in our research: *Cape Charles: A Railroad Town* (Hickory House, 2004) by Jim Lewis; *The Eastern Shore of Virginia* (The Eastern Shore News, 1964) by Nora Miller Turman; *The Countryside Transformed* Web site (eshore.vcdh.virginia.edu); *An Economic and Social Survey of Northampton County* (University of Virginia, 1927) by C. W. Holland Jr., N. L. Holland, and W. W. Taylor; *History of Steamship Navigation to the Eastern Shore of Virginia* (Dietz Press, 1973) by A. Hughlett Mason, and *Eastern Shore Railroad* (Arcadia 2006), by Chris Dickon.

INTRODUCTION

Shortly after European colonists landed at Jamestown in 1607, they established a settlement on the Eastern Shore in what is today Northampton County. Capt. Samuel Argoll explored the area and reported "a great store of fish, both shellfish and other." For the colonists at Jamestown, the discovery was vital. The young settlement was on the verge of starvation, and Northampton's "great store of fish" would save lives. Equally important, the barrier beaches along the county's southern tip were a great source of sea salt, a commodity the early colonists needed to preserve the largesse of summer months for the bleak days of winter. Peter Reverdy, an expert at salt making, established a salt production camp on Mockhorn Island that used the power of the sun to distill salt from sea water. It could be said that Northampton had the first solar-powered industry in America.

Since 1608, Northampton has provided food for Virginia and for the world. The county has the Atlantic Ocean and the barrier islands on its eastern boundary and the Chesapeake Bay and its tributaries to the west. So for centuries, the people of Northampton have used the bounty of this resource to drive their economy. Fishing, crabbing, and clam aquaculture today are still an important part of the economic backbone of Northampton. But perhaps Northampton has been best known in recent years for land-based food production. The sandy soils of Northampton have always been productive, but when the railroad was built in 1884 it gave growers a method of getting produce to markets in a timely manner. The Eastern Shore of Virginia Produce Exchange opened in 1900 and established a marketing system that partnered with the railroad to send potatoes, strawberries, cucumbers, cabbages, and other vegetables through the eastern United States and into Canada.

The railroad also ushered in the modern era of tourism, and hotels and hunting clubs quickly sprang up. Among the most famous were the Cobb family hotel on Cobb's Island and the Broadwater Club on Hog Island, which was a favorite of Pres. Grover Cleveland, who spent quite a bit of time there.

Numerous towns grew along the railroad and became shipping points for seafood and produce to be delivered throughout the east. Exmore, in the northern part of the county, was a railroad town and a marketing center where vegetables were brought for processing, canning, and shipping. Fish, clams, and crabs were brought by fishermen to the docks at nearby Willis Wharf and trucked to Exmore for shipment to city markets in refrigerated rail cars. Salty seaside oysters were shucked and shipped to northern restaurants in gallon containers.

One particular town in Northampton was a special child of the railroad. Cape Charles, a deepwater port on the bay, became a hub of the New York, Philadelphia, and Norfolk (NYP&N) Railroad. An elegant station was built, along with numerous shops, a roundhouse, and freight warehouses. Rail barges were constructed, and Cape Charles became the shipping center of the Eastern Shore. Trains came by rail to Cape Charles, and the cars were loaded onto barges that were towed by tugboats to the railroad terminal in Norfolk, where they made connections for points south.

Growth came quickly for Cape Charles, and within only a few years the area went from a bucolic bayside expanse of fields and forest to a young city. Indeed, the town was christened Cape Charles City, paying tribute to the actual cape where bay meets ocean at the tip of the peninsula a few miles south. Cape Charles City was very much a frontier town in those days, with each arrival of the train bringing in strangers from north and south to share in the commerce of the area. Cape Charles quickly became the fastest-growing town on the Eastern Shore, something of an anomaly in Northampton County, where southern gentility usually prevailed and where change came only after thoughtful and measured diligence.

But Cape Charles was a boom town, a flame ignited by the railroad, and for a few decades it burned with a memorable intensity—until, of course, the railroad left and that flame became a flicker. Cape Charles today has reinvented itself as a resort and golfing center, a community with nice restaurants, galleries, and shops. Looking closely at the architecture, at the old businesses and fine homes along the tree-lined streets, a little of the frontier spirit of Cape Charles City can still be seen.

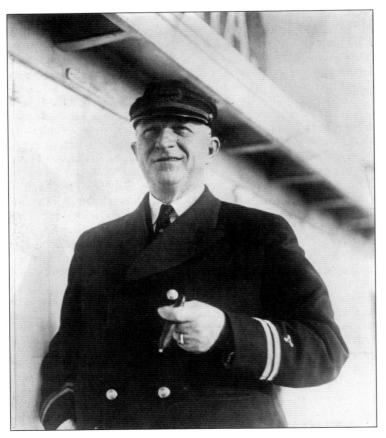

Northampton County has always had a close relationship to the waters that surround it. That relationship underwent a radical change in 1884 when the New York, Pennsylvania and Norfolk (NYP&N) Railroad began operation. Cape Charles became a railroad hub, a busy place where the railroad and the steamships joined operations. Ship officers were highly respected leaders of the business community. This gentleman is V. H. Ward, chief engineer of the steamer *Pennsylvania*. (Nut Redden collection; courtesy of CCHS.)

One

BOATS AND BUSINESS

Surrounded by water, Northampton County has a history that is largely defined by the bay and the ocean and the boats and ships used for both business and pleasure. The barrier islands of Northampton's seaside provided food and salt for the Jamestown colony. The shallow bays later became an important element of the county economy. Crabs, clams, oysters, and fish were caught and shipped to market by sailing ship and later steamship and railroad. The creeks on the bayside of the peninsula also provided seafood, and an avenue of commerce, as ships brought goods from cities and exported farm produce and other commodities, as well as passengers.

Fisherman Island, at the very tip of the peninsula, was once a quarantine station where immigrants coming to America by boat were screened for infectious disease. Fisherman Island later became a part of America's defense system during World War II when huge guns placed there defended the mouth of the bay against enemy warships.

When the railroad opened in 1884, it authored yet another chapter in Northampton's nautical heritage. The railroad needed a direct link with southern cities, and this was accomplished by railroad barge. A large harbor was constructed at Cape Charles, and railroad cars were loaded onto barges and towed to Norfolk by tugboat. As car travel became popular in the early 20th century, ferries were used to transport automobiles and passengers from Cape Charles to Port Norfolk and Little Creek. In 1950, a ferry terminal was built at Kiptopeke, where it remained until the Chesapeake Bay Bridge-Tunnel opened in 1964.

The railroad era and the age of the passenger ferry were closely related. Travelers came to Cape Charles by rail and would then board passenger ships for a leisurely crossing of the Chesapeake Bay. Old photographs indicate that boat travel provided all the comforts and a few luxuries as well. Passengers could dine on fresh local seafood or on the finest cuts of beef, and meals were served on linen tablecloths and fine china. People tended not to be in a hurry in those days, when transportation was not simply a means of getting from place to place, but a journey to be savored and enjoyed.

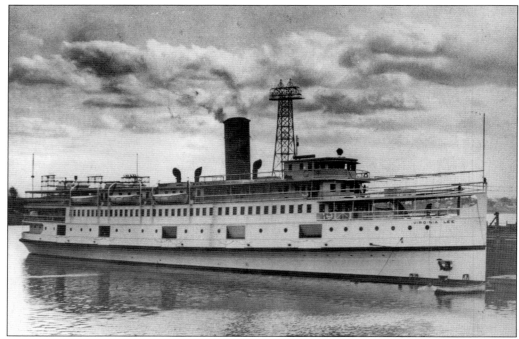

The steamship *Virginia Lee* was built in 1928 for the Pennsylvania Railroad and was named for the daughter of Elisha Lee, an official of the railroad. She ferried passengers between Cape Charles and Norfolk until World War II, when she was requisitioned by the government and used on the Amazon to transport rubber. After the war, the *Virginia Lee* was extensively renovated, renamed the *Accomac*, and put back to work on the capes until the bridge-tunnel opened in 1964. (Robert Lewis collection; courtesy of CCHS.)

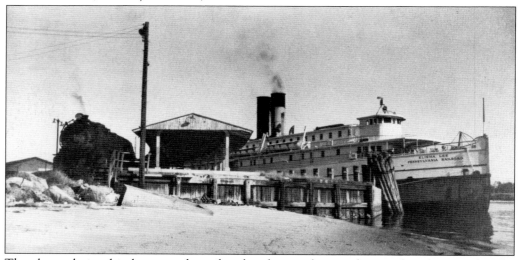

The close relationship between the railroad and steamships is clear in this photograph. The Delmarva Express is on the left, alongside the steamer *Elisha Lee*. The *Elisha Lee* was built in 1892, originally named the *Richard Peck*, and was used as an excursion boat on Long Island Sound. She was refurbished and became part of the local fleet in March 1944, capable of carrying 1,200 passengers and 75 vehicles. (Robert Lewis collection; courtesy of CCHS.)

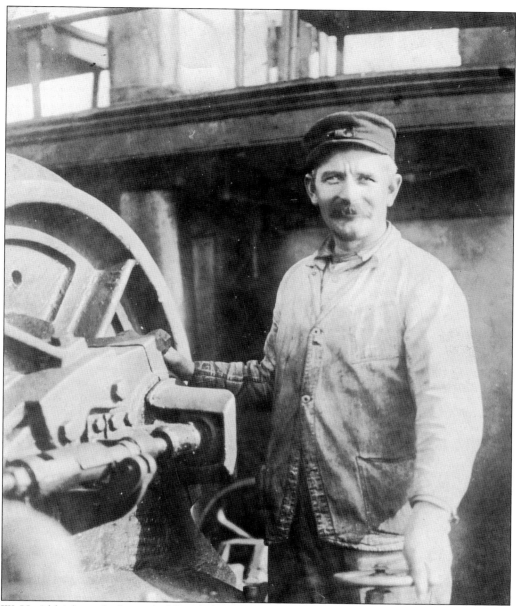

W. H. Aldrich worked as a deckhand aboard the tug *Cape Charles* in 1925. When the railroad opened in 1884, it created hundreds of new jobs. Business was booming in Northampton, thanks to the railroad, the potato industry, and the marketing efforts of the Eastern Shore of Virginia Produce Exchange, which opened in 1900. In 1890, more than 30,000 railroad cars were barged across the bay. That number grew to 46,000 in 1900, and by 1920 the number of cars was more than 250,000. The *Cape Charles* was averaging more than 100 crossings a month. Those were prosperous years for farms and local businesses, and work was plentiful for anyone needing a job. (Nut Redden collection; courtesy of CCHS.)

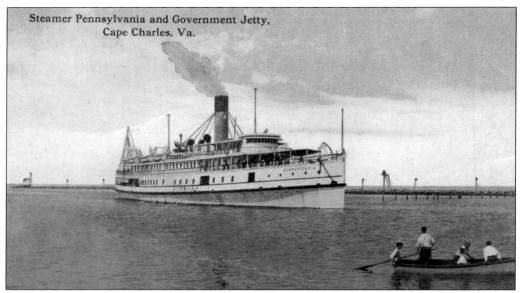

The steamship *Pennsylvania* was commissioned by the NYP&N Railroad and was built in 1900 in Chester, Pennsylvania. She was a very fast steamer with luxurious interior appointments and was one of the most popular vessels in the early 1900s. Here she makes her way into Cape Charles harbor, passing the government jetty on the right. The *Pennsylvania* was dismantled in 1940, but her steam whistle can be seen at the Mariners' Museum in Newport News. (Courtesy of Carl Bundick.)

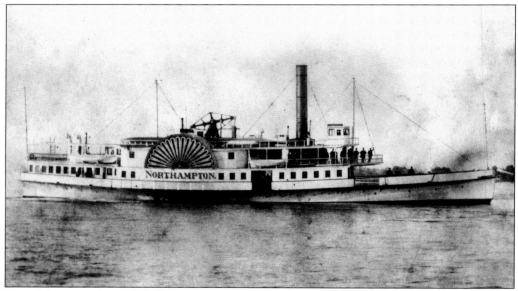

One of the original steamships linking Northampton County with points south was the appropriately named *Northampton*. This side-wheeler was built in 1880 in Greenpoint, New York, for Old Dominion Steamship Company and was used in Northampton prior to completion of the railroad in 1884. Her captain was John R. Trower. A second *Northampton* was used as a ferry between Kiptopeke and Little Creek in the 1950s. (Courtesy of Mariners' Museum, Newport News, Virginia.)

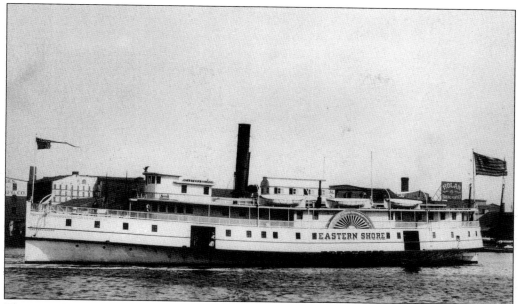

The steamship *Eastern Shore* was not a railroad ferry, but she was one of the most beloved steamboats that operated in the two counties for more than 50 years, hauling thousands of barrels of Irish potatoes from Eastern Shore farms to markets in Baltimore and beyond. She was built in Wilmington, Delaware, for the Eastern Shore Steamboat Company of Baltimore in 1883 and burned at Great Bridge, Virginia, in 1949. (Courtesy of Mariners' Museum, Newport News, Virginia.)

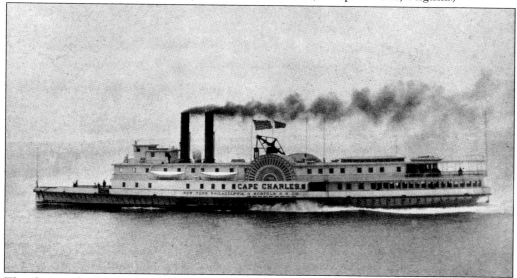

The chartered side-wheeler *Jane Mosely* was the first steamship used by the railroad for the Cape Charles to Norfolk run, but the *Cape Charles*, shown here, was the first steamship constructed specifically for the NYP&N Railroad. She was built in Wilmington in 1885 by Harlan and Hollingsworth and included a deck with rails to accommodate four sleeping cars. The *Cape Charles* was used locally for several years and was then sold to the state of New York. She was last used in Gulfport, Mississippi, and was condemned there in 1918. (Courtesy of Mariners' Museum, Newport News, Virginia.)

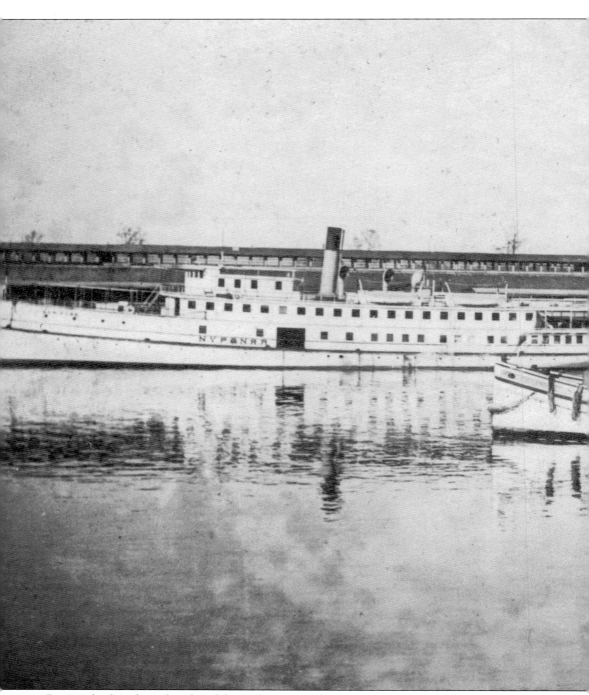

During the first three decades of the 20th century, Northampton was one of the most prosperous rural counties in the United States, ranking among the top producers of white potatoes and sweet potatoes. Cape Charles, as seen here, was a fast-growing port city, a shipper of produce, and a vital link in north-south rail travel on the coast. Cape Charles grew with the railroad, which opened in 1884, and by 1900 the population had grown to more than 1,000. In the background of this

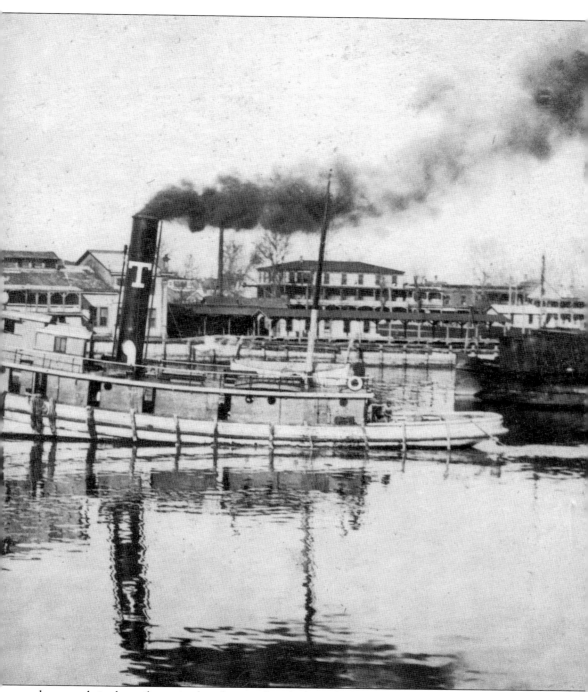

photograph is the rail terminal and steamship dock, with the steamer *New York* tied up at the pier. The *New York* was built in 1889 for the NYP&N Railroad and was the first propeller-driven steamer in the passenger fleet. In the right foreground is one of the tugs used to tow rail barges across the bay. (Courtesy of CCHS.)

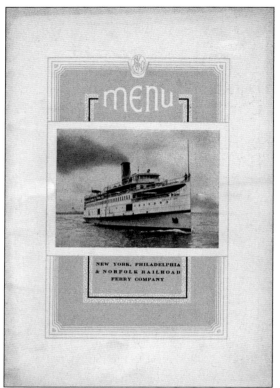

At the height of passenger rail service in Northampton County, travel was considered a journey to be enjoyed, not simply a means of getting from one place to another. The railroad had dining cars and sleeper cars, and passengers could enjoy a good meal and a restful night. This is the menu from the *Virginia Lee*, which had comforts befitting a ship named for the daughter of a top railroad official. (Nut Redden collection; courtesy of CCHS.)

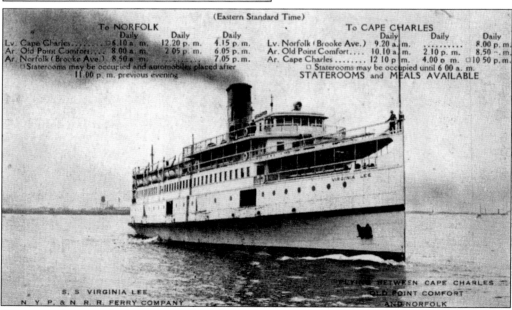

The same photograph that appeared on the menu cover of the *Virginia Lee* also was used on the steamship schedule. The crossing between Norfolk and Cape Charles took about two hours. Staterooms were available for passengers who wanted to take a nap during the trip. (Courtesy of CCHS.)

Eggs and Omelets	Boiled, Fried, Shirred or Scrambled (2) 30 Cheese Omelet 45 Plain Omelet (2 Eggs) 35 Ham or Jelly Omelet 50 Poached Eggs on Toast (2) 40 Scrambled Eggs with Shad Roe 60

~•~

Steaks, Chops, Etc.	Sirloin Steak 1.00 Minute Steak 60 Lamb Chop (Double) 45 Ham or Bacon 45 (With two Eggs 60) Smithfield Ham 60 (With two Eggs 75) Country Sausage 45

~•~

Sea Food	Fish: Broiled or Fried 50 Shad Roe with Bacon 75 Filet of Salt Mackerel 60 Kippered Herring on Toast 40 Cod Fish Cakes (one) 25 (two) 45

~•~

Potatoes	Creamed 25 French Fried 25 Mashed 15 Hashed in Cream 25 Hashed Browned 20

~•~

Bread, Toast, Etc.	Wheat Muffins, Whole Wheat or Corn 10 Boston Brown Bread 15 Buckwheat, Wheat or Corn Cakes with Syrup 25 Honey 30 French Toast with Syrup 25 French Toast with Honey 30 Waffles with Syrup 35 Honey 40 Milk Toast 25 Rolls, Hot or Cold 10 Vienna, Rye, Raisin or Graham Bread 10 Dry or Buttered Toast 10 French Toast with Currant Jelly 25

~•~

Coffee, Tea, Etc.	Kaffee Hag or Sanka Coffee (Cup) 10 (Pot for one) 15 (Pot for two) 25 Coffee (Cup) 10 (Pot for one) 15 (Pot for two) 25 Cocoa (Cup) 10 (Pot for one) 15 (Pot for two) 25 Tea: Orange Pekoe, English Breakfast, Oolong or Mixed (Cup) 10 (Pot for one) 15 (Pot for two) 25 Instant Postum (Cup) 10 Milk (Glass) 10 Iced Tea (Glass) 10

~•~

Pay only upon presentation of check; see that extensions
and totals are correct.

Guests aboard the *Virginia Lee* could have shad roe with bacon for 75¢, and a glass of milk cost a dime. The most expensive item on the menu was a sirloin steak at $1. Prices, however, are relative to one's income. In the early days of the railroad, captains and chief engineers on the steamships made about $110 a month, while deckhands, firemen, and oilers were paid $35 a month. Railroad and steamship employees were provided lodging and meals while at work, although shad roe and bacon were probably not available on their menu very often. (Nut Redden collection; courtesy of CCHS.)

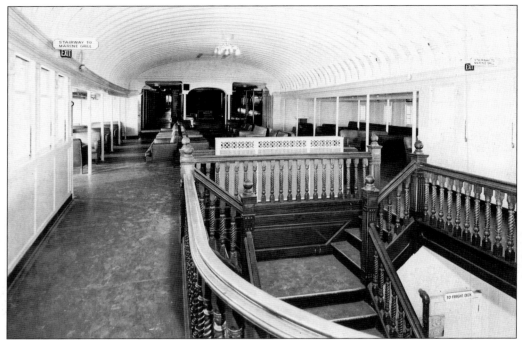

In late 1943, Pennsylvania Railroad, the successor to NYP&N, purchased a steamship built in 1892 named the *Richard Peck*. PRR immediately sent the steamer to Norfolk Shipbuilding and Drydock Corporation for a complete refitting. The renovated ship, renamed the *Elisha Lee* in honor of a former railroad administrator, was a handsome steamer, complete with ornate woodwork and leather-trimmed seating. (Nut Redden collection; courtesy of CCHS.)

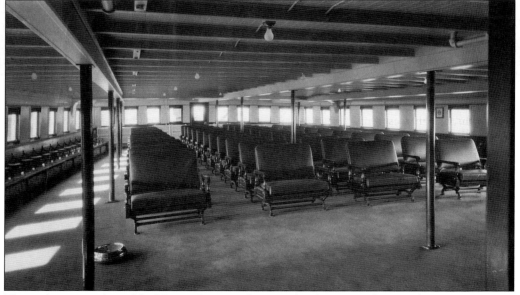

This is the main salon of the *Virginia Lee* in a photograph taken around 1940. The seating appears comfortable, if not nearly as ornate as that of the *Elisha Lee*. (Nut Redden collection; courtesy of CCHS.)

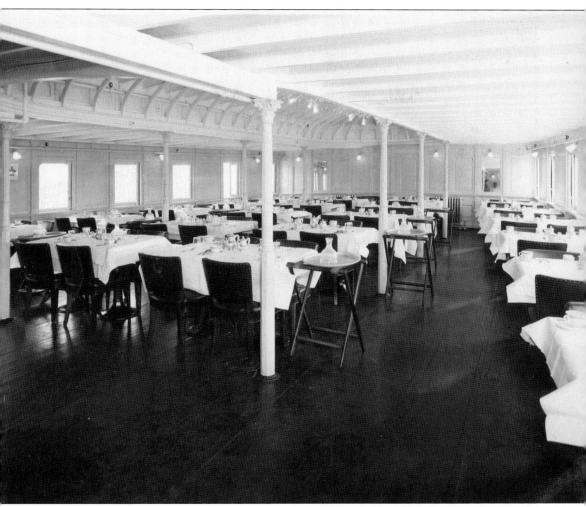

This photograph, taken in 1944, shows the main dining room of the *Elisha Lee* shortly after the ship had been renovated. The dining room, called the Marine Grill, had fine woodwork, linen tablecloths, and the best china. The *Elisha Lee* was one of the oldest ships in the fleet, but after its extensive renovation it became the star of the line. At more than 300 feet in length, it was the largest ship ever to come into Cape Charles harbor. Beach glass collectors today frequently find bits and pieces of old china and glassware discarded from the kitchens of the *Elisha Lee* and other steamships of the era. (Nut Redden collection; courtesy of CCHS.)

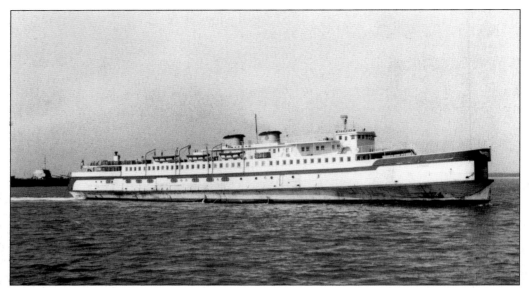

After World War II, the *Virginia Lee* was renamed *Holiday* and used as an excursion boat. She was damaged in heavy seas off the Carolina coast in 1951, towed to Morehead City, and was purchased by the Virginia Ferry Corporation. After an extensive renovation, she looked as she does in this photograph. The steam engines were replaced by two diesel engines, the name was changed to the *Accomac*, and she ferried passengers and vehicles across the bay until the Chesapeake Bay Bridge-Tunnel opened in 1964. (Robert Lewis collection; courtesy of CCHS.)

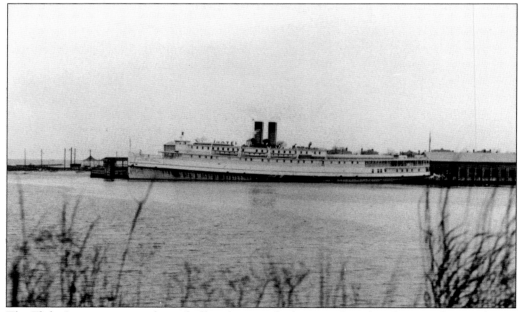

The *Elisha Lee* was nearing the end of her distinguished career when this photograph was taken at the Cape Charles harbor in 1953. In February of that year, the ship failed a coast guard inspection, and the Pennsylvania Railroad decided against spending the $600,000 estimated for repairs. In October, she was sold for scrap to Bethlehem Steel Company in Baltimore. Her last captain was H. C. Hundley. (Robert Lewis collection; courtesy of CCHS.)

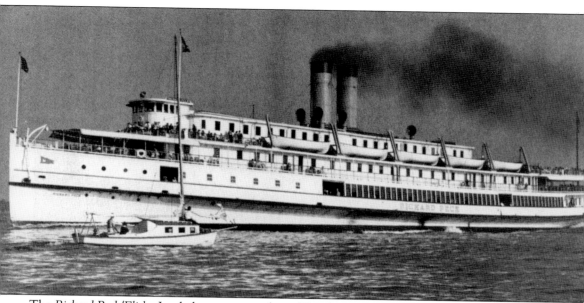

The *Richard Peck/Elisha Lee* led two separate lives. The ship was built in 1892 in Wilmington by the well known shipbuilder Harlan and Hollingsworth for the New England Steam Ship Company for service on Long Island Sound, where she served for many years. This photograph, probably taken in the early 1940s, shows the *Richard Peck* with one if its last group of passengers. The ship went to work for Pennsylvania Railroad in 1944 as the *Elisha Lee*, beginning its second life on the Chesapeake Bay. (Robert Lewis collection; of the CCHS.)

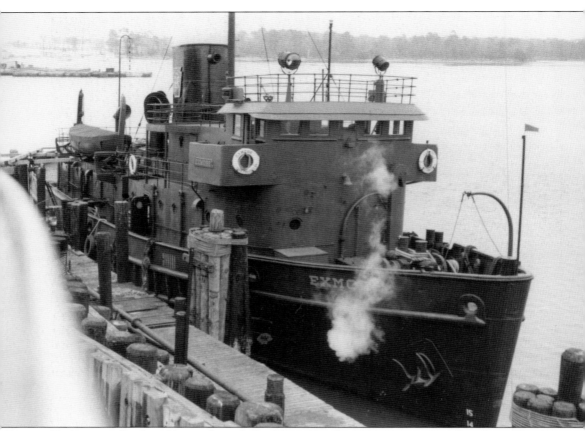

Tugboats and railroad barges have helped keep Northampton's economy afloat for well over a century. When the railroad was completed down the Eastern Shore to Cape Charles, it soon followed that rail cars were barged across the bay to Norfolk to resume southbound trips. The first tug and barge trip took place on March 12, 1885, just a few months after the final tracks were laid. Since then, tens of thousands of rail cars have been loaded onto barges and towed across the Chesapeake to make connections in Norfolk and Portsmouth. During the height of the white potato season in the early 1900s, extra tugs and barges were leased from companies as far away as New York to handle the volume of traffic. This is the tug *Exmore*, which was built in 1942 for the U.S. Maritime Commission and purchased by the railroad in 1946. (Robert Lewis collection; courtesy of CCHS.)

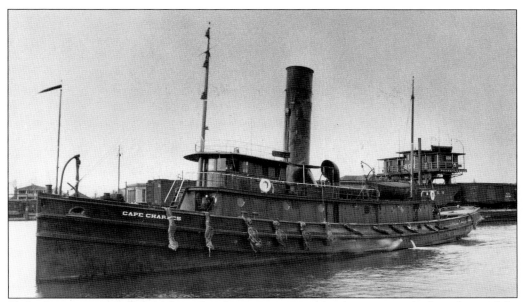

Elisha Lee, superintendent of the railroad, was instrumental in having a tug built and named for the city of Cape Charles. In March 1910, some two dozen prominent residents of Cape Charles were guests of Elisha Lee for the christening of the tug *Cape Charles* at the J. H. Dialogue and Son shipyard in Camden, New Jersey. The *Cape Charles* was a real moneymaker for the railroad, averaging more than 100 bay crossings a month. (Courtesy of Mariners' Museum, Newport News, Virginia.)

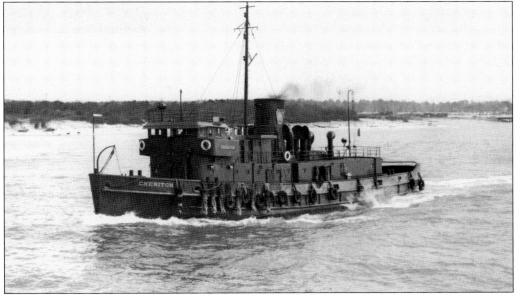

The tug *Cheriton*, named for another Northampton town, is another World War II vintage boat, purchased from the U.S. Maritime Commission, as was the *Exmore*. Both tugs were built by the Marietta Manufacturing Company of Point Pleasant, West Virginia, to similar specifications. Both were 142.2 feet in length and powered by 1200-horsepower steam engines. (Robert Lewis collection; courtesy of CCHS.)

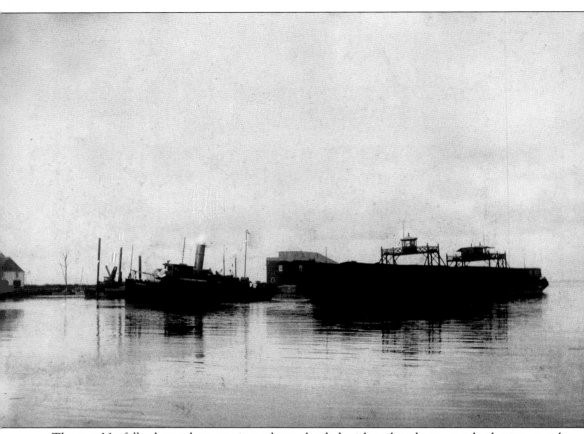

The tug *Norfolk*, shown here towing a barge loaded with railroad cars, made the inaugural crossing from Cape Charles to the port of Norfolk in March 1885, beginning a shipping business that revolutionized industry in Northampton County as well as all of the Delmarva Peninsula. Agriculture, chiefly the growing of white and sweet potatoes, was the predominant industry, and the railroad and the barges provided farmers a way of getting their product to market. The *Eastern Shore News* reported in June 1926 that rail traffic set records that May, with 19,557 loaded rail cars making the crossing between Cape Charles and Norfolk. Those were prosperous days for Northampton and for the railroad. The Pennsylvania Railroad, which took over the local rail in 1922, was at one time the largest publicly traded corporation in the world. (Nut Redden collection; courtesy of CCHS.)

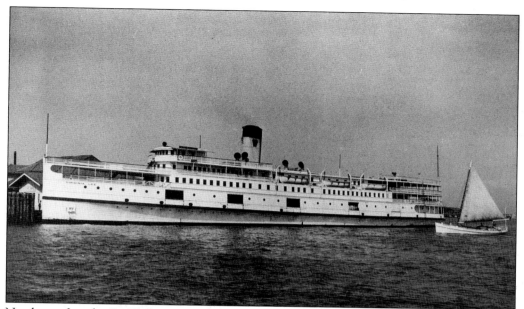

Not long after the Pennsylvania Railroad merged with NYP&N, the company commissioned the Fore River Works of Bethlehem Steel to build the *Virginia Lee*. This picture was taken at the Cape Charles docks around 1930, shortly after she was put into service. (Courtesy of Mariners' Museum, Newport News, Virginia.)

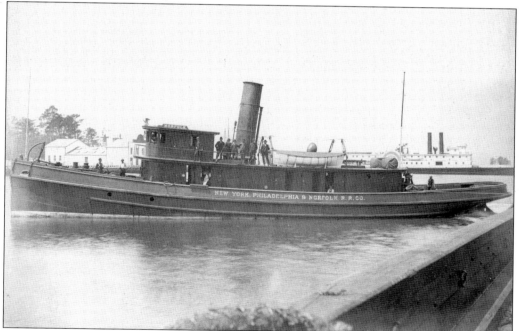

The tug *Norfolk*, with its crew of 12, made the initial crossing of the bay in 1885, shortly after she was built by Harlan and Hollingsworth of Wilmington. The following year, the tug *Portsmouth* joined the fleet. Both boats were very similar, with a length of about 116 feet and powered by a 915-horsepower steam engine. (Courtesy of Hagley Museum and Library.)

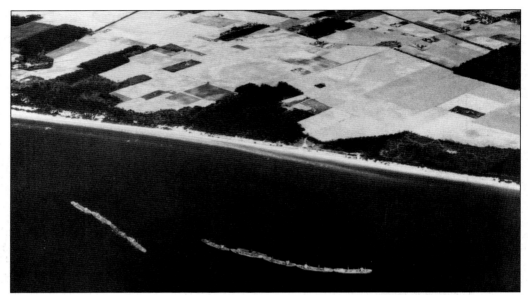

If the 1920s was the decade of growth for Northampton, the 1950s was the decade of change and, for Cape Charles, the decade of decline. Farther south on the bay, other changes were taking place. This aerial view is of Kiptopeke Beach, where construction was underway in 1950 on a new ferry terminal. The breakwater of World War II–era concrete ships was in place when this photograph was taken. (Robert Lewis collection; courtesy of CCHS.)

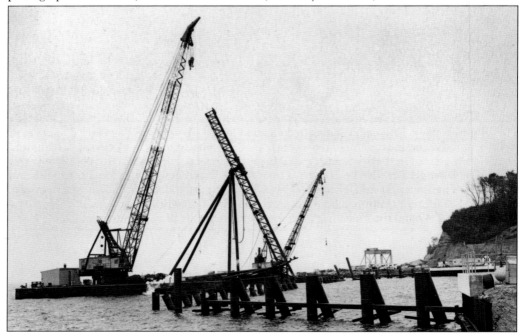

Behind the breakwater, a pier was constructed with berths for docking ferries and a terminal building where travelers could relax and have a bite to eat. Ferries sailed from here until the Chesapeake Bay Bridge-Tunnel opened in 1964. The site is now Kiptopeke State Park, and a fishing pier is currently on the site of the old terminal building. (Courtesy of CCHS.)

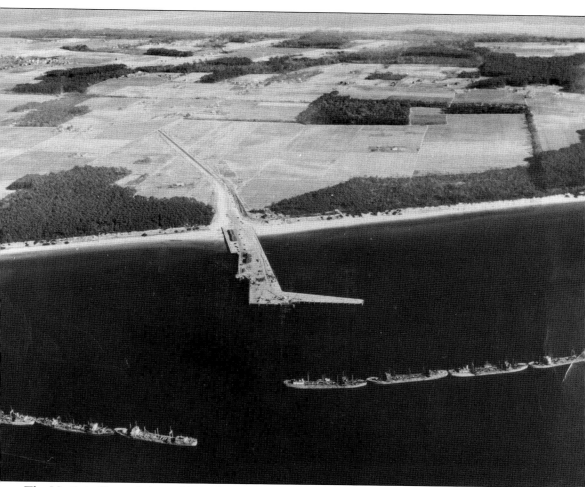

The Virginia General Assembly authorized creation of the Chesapeake Bay Ferry Commission in 1954, and the commission took over operation of the ferry from its predecessor, the Virginia Ferry Corporation. The service from Kiptopeke was nearly set to begin when this photograph was taken. The Kiptopeke service began with a fleet of five ferries designed to handle vehicles and passengers. They included the *Delmarva, Princess Anne, Pocahontas, Northampton, and Accomac.* Service to Little Creek continued from Cape Charles for a short while, but the steamer *Maryland* was retired in 1949 and the *Elisha Lee* made her final voyage in 1953. (Courtesy of CCHS.)

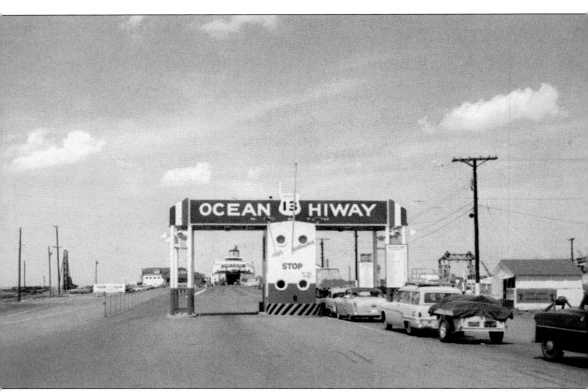

Stop at the toll booth, buy a ticket, and drive onto the ferry. In the years following World War II, Americans became mobile. Nearly every family had at least one car, and public transportation, such as rail travel, was declining. Crops were being shipped to market by trucks, and the golden age of railroad and steamship was nearing its end. Ferry travel continued in Northampton for more than a decade after the Kiptopeke facility opened. When the bridge-tunnel opened in 1964, many of the ferries were sold to the Delaware River and Bay Authority, which established ferry service between Lewes, Delaware, and Cape May, New Jersey. (Courtesy of Danny Phillips.)

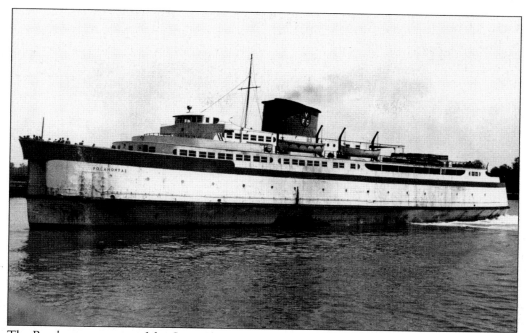

The *Pocahontas* was one of the Cape Charles ferries that moved its home port 7 miles south when the Kiptopeke terminal opened in May 1950, leaving only the *Elisha Lee* to handle the dwindling passenger business traveling by rail. (Courtesy of Mariners' Museum, Newport News, Virginia.)

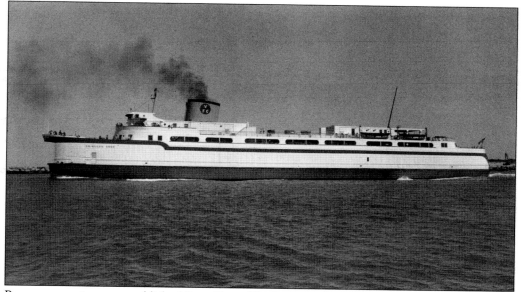

Passenger service was established from Cape Charles to Little Creek in 1933. Little Creek was a new terminal and was a shorter route by water than the old terminal at Port Norfolk. Ferries for this run were designed to accommodate cars and trucks, the first of which was christened the *Delmarva*. The *Princess Anne*, shown here, went into service in May 1936. (Courtesy of Mariners' Museum, Newport News, Virginia.)

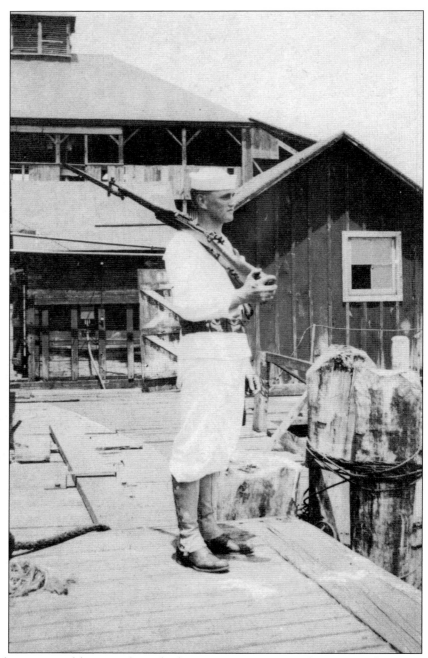

While the army, and later air force, had a major presence on what is now the site of Eastern Shore of Virginia National Wildlife Refuge, the navy at one time had a base on Sandy Island, or Cherrystone Island, near Cape Charles. When World War I broke out, the navy took over the Dennis Fish Oil property on the island and established an officer training school, a lookout station, and a gas engine repair school. By late 1917, about 200 navy personnel were stationed on the island. Here a sailor stands watch with the old fish processing plant in the background. (Bill Neville collection; courtesy of CCHS.)

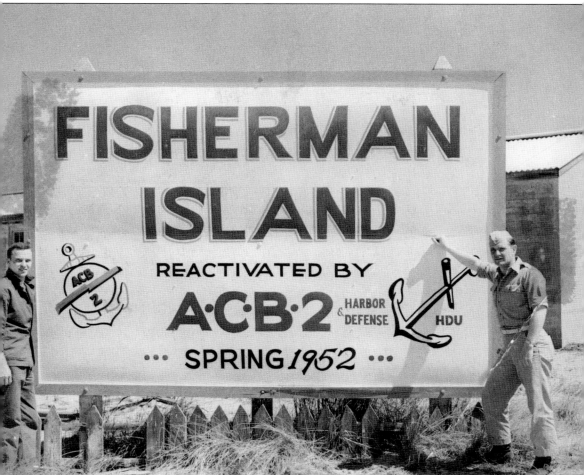

Fisherman Island is at the very tip of the Delmarva Peninsula, making it a strategic location for military and other purposes. In February 1897, the Richmond *Dispatch* reported that heirs of the Wise family sold the island to the federal government for $5,000. The government planned to use the island as a quarantine station and build a hospital to screen immigrants coming into the country. Gun emplacements, lookout towers, and bunkers were built on the island during World War II to protect the Chesapeake Bay from enemy ships. The island was still playing a role in national harbor defense when this picture was taken in 1952. Today thousands of people pass through Fisherman Island each day when traveling on the Chesapeake Bay Bridge-Tunnel. The island, however, is off limits to foot travel and is protected as a national wildlife refuge, part of Eastern Shore of Virginia National Wildlife Refuge. (Courtesy of U.S. Fish and Wildlife Service.)

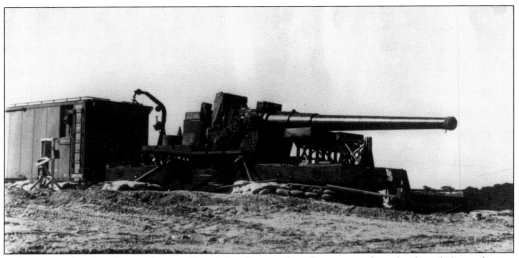

Fisherman Island and neighboring Fort John Custis played a major role in harbor defense during World War II. Here an 8-inch railway gun is being installed at Fort John Custis in the early 1940s. The big guns were removed after the war, but the bunkers where they were placed are still there, now part of a trail at the wildlife refuge. A lookout platform atop one of the bunkers provides a great view of the southern tip of the peninsula. (Courtesy of U.S. Fish and Wildlife Service.)

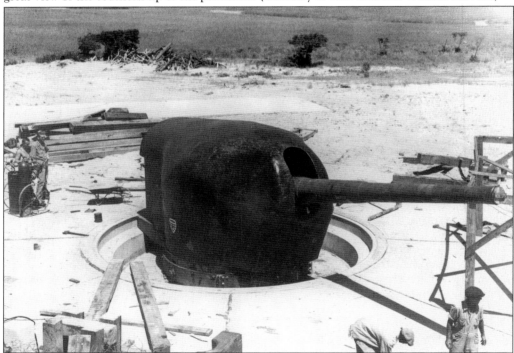

Two 6-inch guns on Fisherman Island guarded the bay during the war. Armaments on Fisherman Island also included four 5-inch guns, two 3-inch guns, two 90mm guns, and four 155mm guns. In addition, there were bunkers, barracks, a dining hall, offices, lookout towers, and a large dock on the northwest side of the island. After the war ended, the 6-inch guns went to the Smithsonian Institution in Washington. (Courtesy of the U.S. Fish and Wildlife Service.)

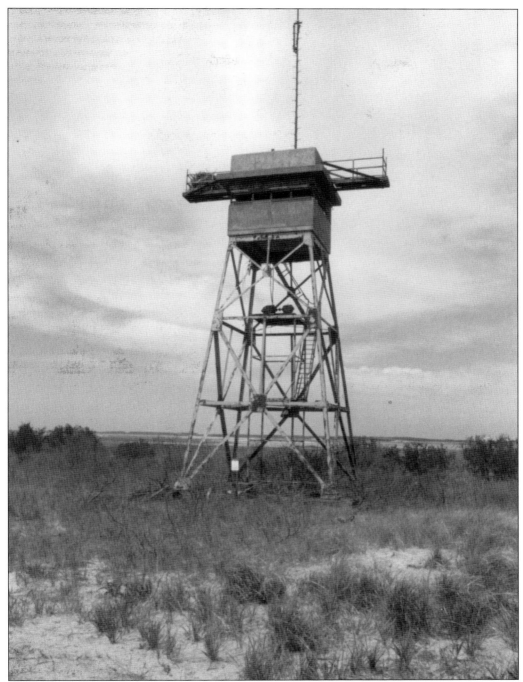

This was one of the lookout towers on Fisherman Island in a photograph taken in the 1970s. The towers and other infrastructure were taken down in a training exercise conducted by U.S. Navy SEALs. The wildlife refuge conducts guided walks on the island in winter, and visitors can still see a few remnants, such as bunkers and concrete pads where the guns were placed and a few pilings from the old dock. (Courtesy of U.S. Fish and Wildlife Service.)

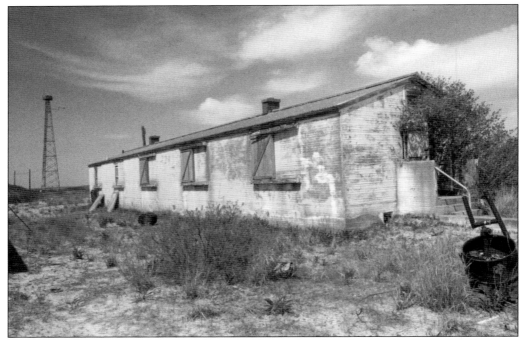

The derelict barracks buildings on Fisherman Island were taken down in the 1970s. A radio tower can be seen in the background. While the island has a strong military history, it is better known today for its importance to wildlife. Each summer, many shorebirds nest in colonies on the beach, and in winter, the shallow waters and salt marshes are home to thousands of migrating waterfowl. (Courtesy of U.S. Fish and Wildlife Service.)

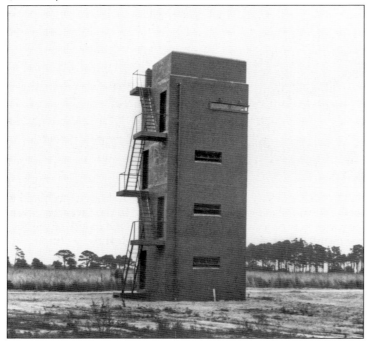

This fire control tower was in use at Fort John Custis during World War II and was taken down after the war. The fort was created when the government acquired 798 acres of farmland and salt marsh on the tip of the peninsula in August 1940. A few reminders of the agrarian past can still be seen there. The small cemetery where the farming families—the Halletts and the Fitchetts— were buried is alongside one of the walking trails. (Courtesy of U.S. Fish and Wildlife Service.)

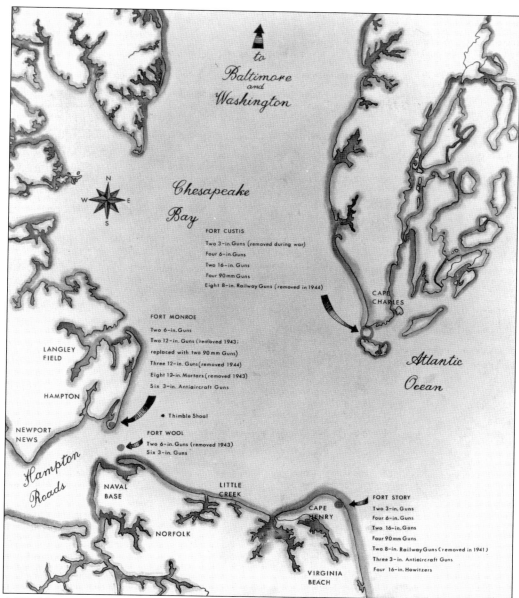

A World War II–era map shows the harbor defenses of the Chesapeake Bay. Fisherman Island is not mentioned, but the armaments on the island were probably included in the inventory given for Fort Custis. Fort Custis, along with Fort Story at Cape Henry, guarded the mouth of the bay, and Fort Wool and Fort Monroe guarded the navy fleet in Hampton Roads and the entrance to the James River. (Courtesy of U.S. Fish and Wildlife Service.)

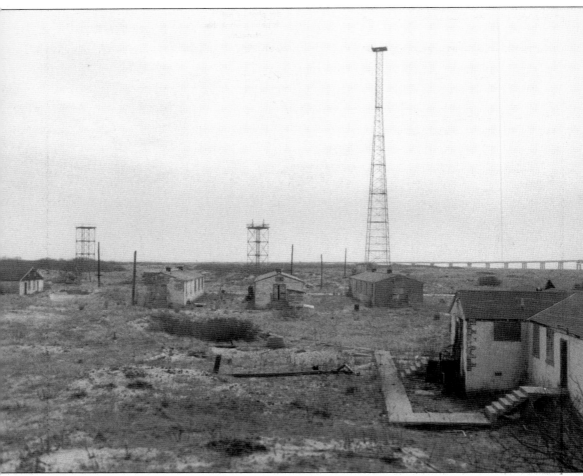

This is probably the final documentation of military presence on Fisherman Island during and after World War II. Not long after this photograph was taken in the 1970s, the buildings and towers shown here were taken down. The Chesapeake Bay Bridge-Tunnel can be seen in the background. (Courtesy of U.S. Fish and Wildlife Service.)

Two

Transportation and Commerce

Northampton is a rural county whose economic backbone is derived from its natural resources. The first European settlers depended upon fish and shellfish for subsistence, as did the Native Americans who were here for centuries before the settlers arrived. As the east coast of America became populated, a market developed for readily available seafood in the Chesapeake Bay and along the barrier islands and shallow bays of the seaside. Soon local people were catching oysters, clams, crabs, fish, and terrapins and shipping them to markets in cities along the bay and beyond. The opening of the railroad in 1884 greatly broadened the market for Northampton County seafood. Fishermen brought their catches to packinghouses in villages such as Willis Wharf, Oyster, and Cherrystone, and fresh seafood was soon on its way to restaurants and markets in Baltimore, Wilmington, and New York.

While the clean, productive waters that surround Northampton have supported the seafood industry for centuries, the fertile, sandy soil of the county has made it one of the most productive agricultural areas in the state. Early on, settlers grew tobacco and corn, and these were soon supplemented by sweet potatoes, white potatoes, cabbage, grains, and, more recently, tomatoes. As with the seafood industry, the coming of the railroad enabled farmers to ship produce to cities all over the eastern United States and Canada. In the 1920s, Northampton and neighboring Accomack County were the leading producers of white and sweet potatoes in Virginia.

Commerce in Northampton closely followed advances in transportation. Before the railroad, life centered around deepwater ports, where crops were brought for shipment to market. The railroad brought the focus of commerce inland, to towns such as Exmore, Nassawadox, and Cheriton, where industries grew around the processing and shipment of food. The opening of U.S. 13 in the 1930s brought about another revolution in shipping, as the focus inevitably moved from railway to the highway. The Chesapeake Bay Bridge-Tunnel opened in 1964, and in an instant Northampton was only minutes away from Hampton Roads, beginning another era of commerce that continues to evolve today.

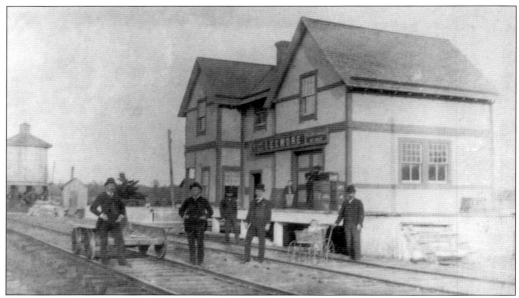

Like Cape Charles, Exmore was a child of the railroad. This was the Exmore train station in a photograph likely taken not long after the railroad came through in 1884. Many of the towns that grew up along the rail line were named for railroad officials, but Exmore probably was not. The traditional notion is that Exmore was so named because it was the tenth stop south of Delmar. (Courtesy of Exmore Centennial committee.)

These unidentified young men gathered on the dock of the Exmore station not long after the railroad opened. Exmore quickly became the commercial center of the northern part of the county. Potatoes and other produce were brought from farms for shipment to market, and oysters, clams, and fish came from nearby Willis Wharf, Thomas' Wharf, and the Hog Island village of Broadwater. (Courtesy of Exmore Centennial committee.)

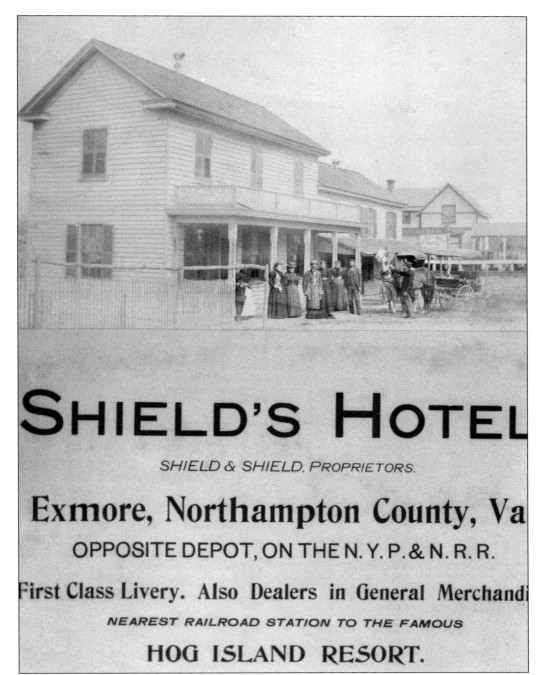

SHIELD'S HOTEL

SHIELD & SHIELD, PROPRIETORS.

Exmore, Northampton County, Va

OPPOSITE DEPOT, ON THE N. Y. P. & N. R. R.

First Class Livery. Also Dealers in General Merchandi

NEAREST RAILROAD STATION TO THE FAMOUS

HOG ISLAND RESORT.

The railroad brought visitors to Exmore, and within a few years hotels, stores, and a wide variety of businesses and services were being offered. People from smaller towns took the train to Exmore for a day of shopping, and traveling salesmen came to sell their wares to Exmore businesses. This advertisement for the Shield's Hotel boasted that it was opposite the NYP&N station in Exmore, the closest station to the famous Hog Island resort. At the time, Hog Island and the village of Broadwater had a population of about 100. (Courtesy of Town of Exmore.)

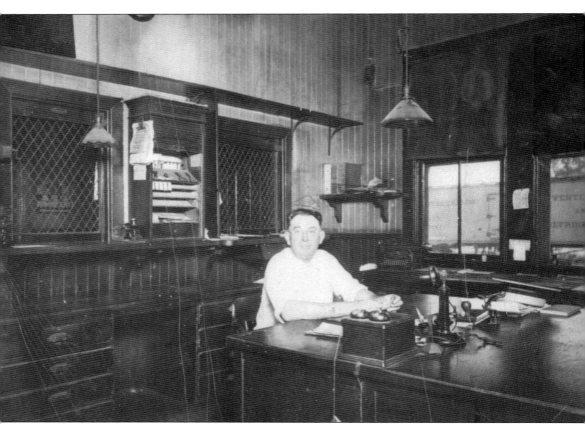

The railroad brought business to Exmore in the early decades of the 20th century, and the station and freight house were busy places, especially in summer when the potato crop was being shipped and seafood was being sent to market. Keeping things moving was the responsibility of the station manager, who was P. R. Wilson when this picture was taken. The box car visible through the window advertised that the cars were ventilated and refrigerated, an important factor when shipping perishable produce such as strawberries and potatoes. Refrigeration also made it safe and practical to ship seafood to market. (Courtesy of Town of Exmore.)

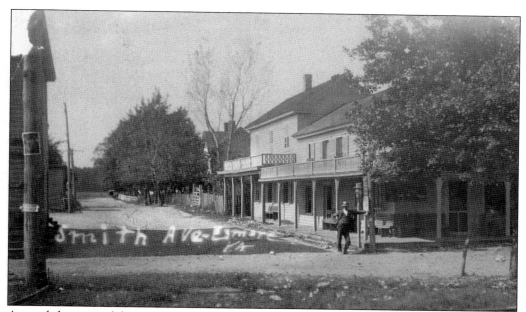

Around the turn of the century, Smith Avenue was the location of the Shield's Hotel. Exmore was experiencing a building boom because people were moving to the area to work on the railroad, to open businesses, or simply to become a part of a thriving new town. Streets were dirt, and gaslights provided evening illumination. Smith Avenue is now Bank Street. (Courtesy of Dave Scanlan.)

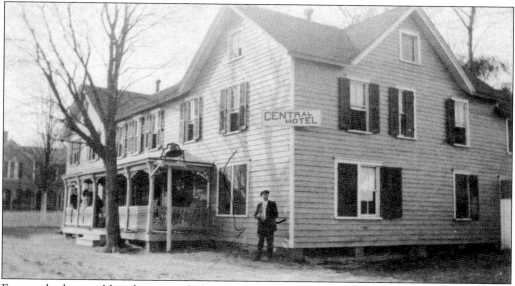

Exmore had several hotels, some of which went by different names during different ownerships. In addition to the Shields' Hotel, there was the Central, shown here, which also was conveniently close to the railroad station. The hotels were popular among drummers, or traveling salesmen, because most provided not only a comfortable bed, but a warm meal at the end of the day. (Courtesy of Dave Scanlan.)

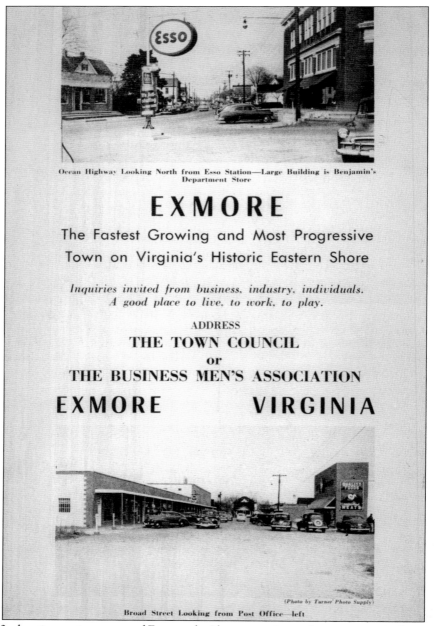

Ocean Highway Looking North from Esso Station—Large Building is Benjamin's Department Store

EXMORE

The Fastest Growing and Most Progressive Town on Virginia's Historic Eastern Shore

Inquiries invited from business, industry, individuals. A good place to live, to work, to play.

ADDRESS
THE TOWN COUNCIL
or
THE BUSINESS MEN'S ASSOCIATION

EXMORE VIRGINIA

(Photo by Turner Photo Supply)

Broad Street Looking from Post Office—left

A *c.* 1940 advertisement pronounced Exmore the "fastest growing and most progressive" town on the Eastern Shore. It made a good point. Exmore not only had the railroad, but it won a political battle in the 1920s when plans were made to extend the Stone Road (now U.S. 13) from the Maryland line to Cape Charles. Some favored a bayside route following the old stage line through Onancock and Pungoteague; others felt it was more practical for the highway to parallel the railroad. The latter group won, and Exmore not only was a thriving railroad town, but also became bisected by the major north-south highway. Industry brought jobs to many, mainly through food processing. The Dulany Company, one of the largest producers of frozen foods in the country, opened a plant in Exmore in 1938 and became a major employer. (Courtesy of Town of Exmore.)

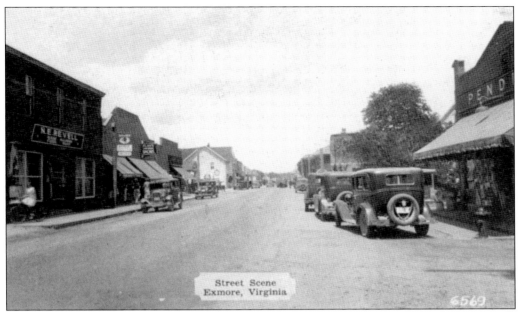

The Stone Road gave Exmore two corridors of commerce: the railroad, and its connection with food processing and shipping, and the highway, which gave rise to numerous businesses such as Pender's grocery store (right), an A&P grocery store, Benjamin's department store, and many other clothing and dry goods stores. A golf course was opened on leased property at Maplewood, south of town, and numerous restaurants opened along the highway. (Courtesy of Carl Bundick.)

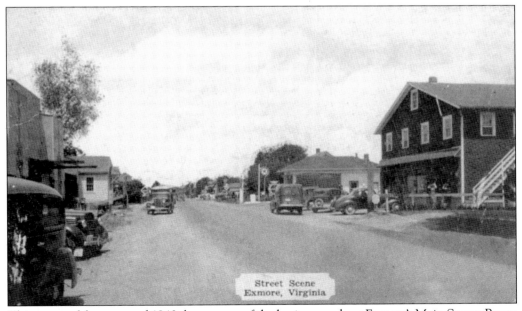

This postcard from around 1940 shows some of the businesses along Exmore's Main Street, Route 13. The large building on the far right was Parks' 5 and 10 and later Elliott Furniture Company. The Justis Texaco station is beyond that. Across the street is Marion's store, where later a Silco and other retail businesses were built. (Courtesy of Dave Scanlan.)

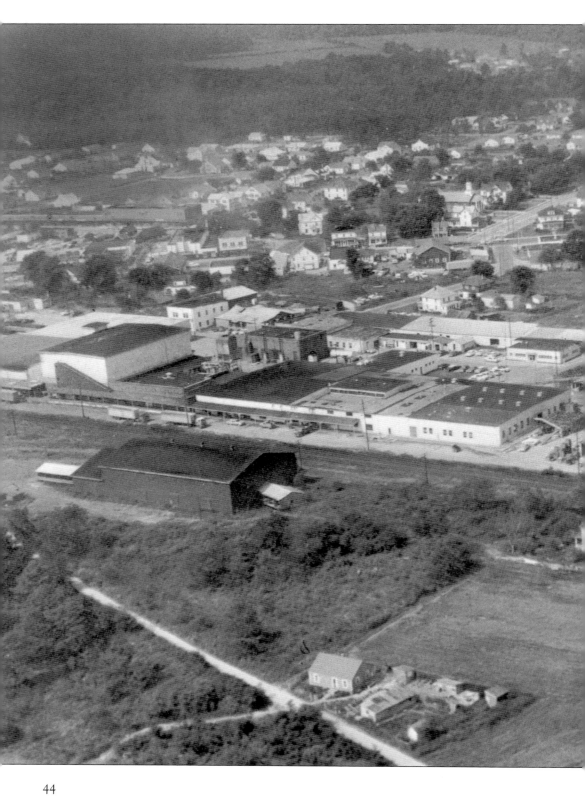

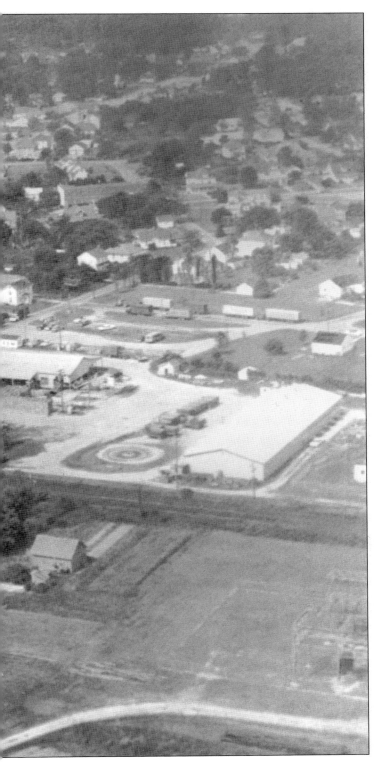

Exmore and Cape Charles were the two most populous towns in Northampton in the mid-20th century. Most of the farm produce grown in lower Northampton was shipped through Cape Charles, while Exmore handled crops in the northern part of the county. This aerial photograph shows the extent to which the town had grown. In the early days of the railroad, a proposal was made to build a spur line to Jamesville and down Occohannock Neck to serve the large farms there, but the spur was never built. The Dulany Company, whose plant is in the foreground here, employed many people during the mid-20th century. It also provided a market for local growers, and it kept the Pennsylvania Railroad busy. In the 1920s, Exmore was shipping annually 125,000 barrels of white potatoes and 75,000 barrels of sweet potatoes. The Exmore Light and Power Company furnished electricity to communities from Cape Charles to Wachapreague, and the Exmore Ice and Storage Company had the capacity of storing 8,000 barrels of seed potatoes, and it provided ice for seafood brought in at Willis Wharf. Exmore also had bottling plants for Coca-Cola and Pepsi companies. (Photograph by Ted Ward; courtesy of Ed Beyersdorfer.)

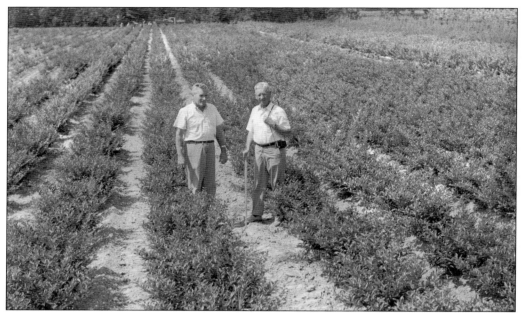

One of the largest businesses in the Exmore area post–World War II was Tankard Nurseries, which was begun by John Ed, left, and Sam Tankard. The two brothers began by selling azaleas and soon branched out into a wide variety of nursery stock. The business is owned today by Ed Tankard, the third generation of the family to be involved in the nursery. (Photograph by Ted Ward; courtesy of Ed Beyersdorfer.)

Potatoes were the cash crop in Northampton during the first half of the 20th century. The Eastern Shore of Virginia Produce Exchange was chartered in 1900 and established a system of grading and marketing potatoes and, working with the railroad, established markets throughout the eastern United States and into Canada. (Courtesy of Carl Bundick.)

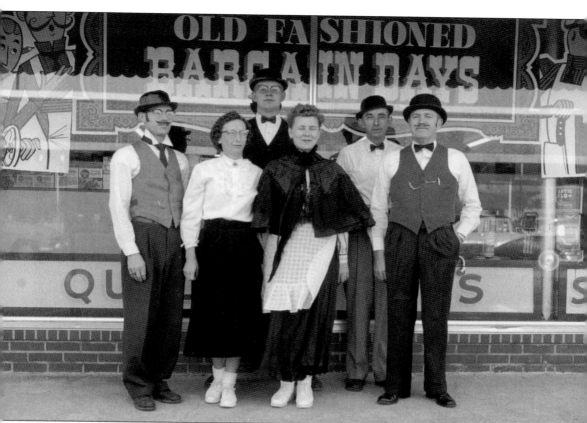

Employees at Colonial Store in Exmore dressed up for "Old Fashioned Bargain Days" in January 1959. From left to right are Jesse Smith, Lois Dix, Jerry Miles, Margaret Brown, Joe Evans, and store manager Henry Lewis. The store had sales on all sorts of items, including country pigs for 33¢ per pound, Wisconsin mild cheddar for 43¢ per pound, and 12 grapefruit for 49¢. (Photograph by Ted Ward; courtesy of Ed Beyersdorfer.)

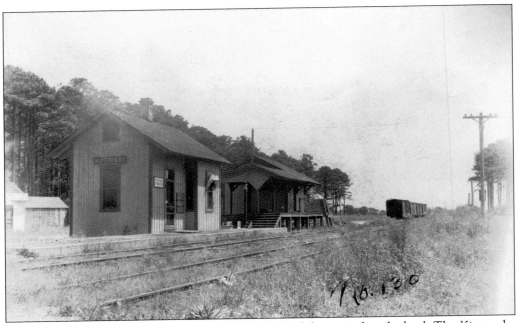

In railroad towns, the station or siding was the hub of the agricultural wheel. The Kiptopeke siding, shown here, was literally at the end of the line. The Kiptopeke spur ran from Cape Charles to the tip of the peninsula. It provided not only shipping, but mail delivery as well. The building on the left was the Kiptopeke post office. (Courtesy of authors.)

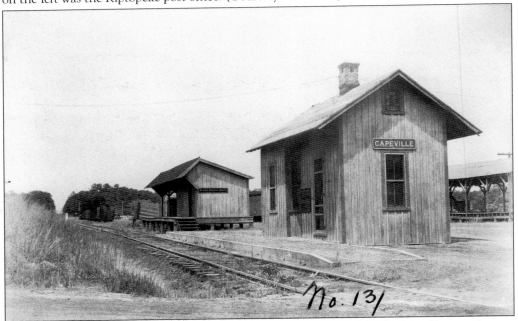

Capeville had a population of about 150 when this photograph of the Railway Express Agency was taken in 1930. Most of the businesses supported the agricultural industry. Frank Parsons and Sons opened business in 1899 as a lumber and cooperage producer and, by the late 1920s, employed as many as 25 workers. (Courtesy of authors.)

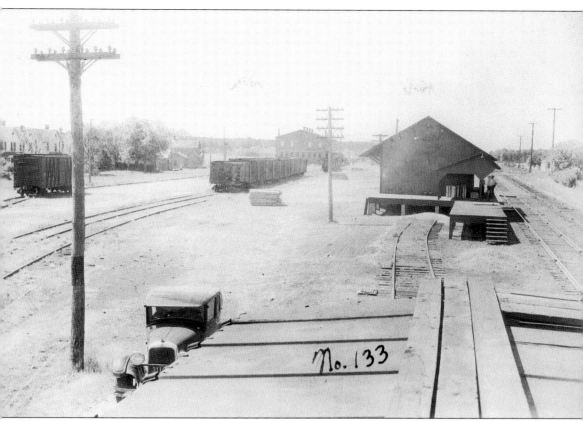

Eastville Station in 1930 was a busy place. The town had been the social and legal center of Northampton since the 17th century, but the opening of the railroad brought about an era of business and manufacturing. The station was located a short distance east of the old town center. By the 1920s, Eastville had a bank, hotel, produce warehouses, a telephone central office, and numerous other businesses. The county newspaper, the *Eastern Shore Herald*, was published in Eastville. (Courtesy of authors.)

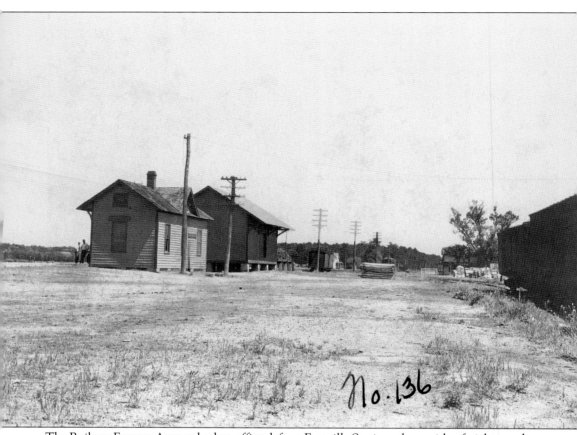

The Railway Express Agency had an office, left, at Eastville Station, along with a freight warehouse. In the background are stacks of dressed lumber awaiting shipment, as well as wooden shipping containers. Nearly every farming community in Northampton had at least one business where barrels and shipping crates were made. (Courtesy of authors.)

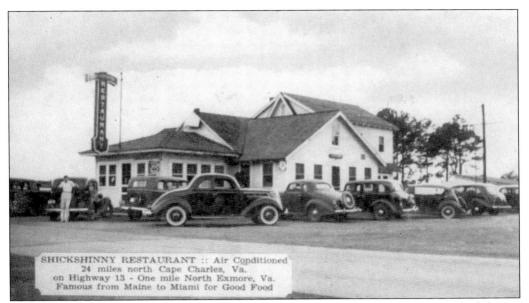

One of the most popular restaurants in the area in the years following World War II was Shickshinny, which was on Route 13 north of Exmore. The curious name was derived from a U.S. merchant marine ship named the *Shickshinny*, on which the restaurant owner, Gordon Savage, served during World War II. Shickshinny is also a borough located in Luzerne County, Pennsylvania. (Courtesy of Carl Bundick.)

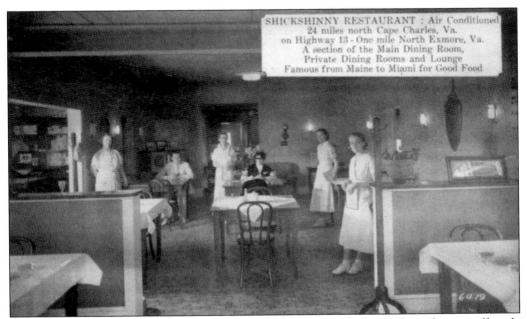

This postcard shows the main dining room of Shickshinny, with the uniformed wait staff ready for customers. Shickshinny was a popular stop among travelers on Route 13 and advertised that it was "famous from Maine to Florida." (Courtesy of Carl Bundick.)

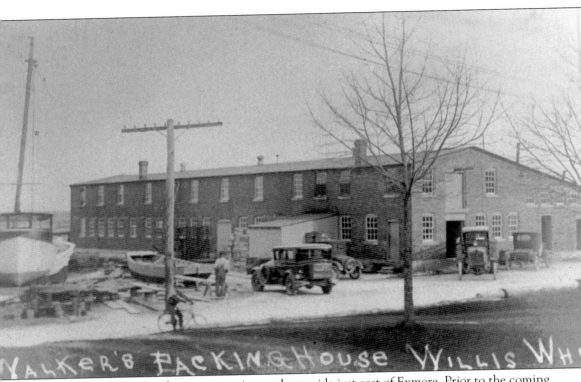

WALKER'S PACKINGHOUSE WILLIS WH.

Willis Wharf is a waterfront community on the seaside just east of Exmore. Prior to the coming of the railroad, this was a busy port town, earlier known as Downing's Wharf and Bigelow's Wharf. Deepwater ports were valuable shipping centers in the pre-railroad days; potatoes, grains, and other goods were brought to Willis Wharf and, farther south, to Thomas' Wharf and Red Bank, for shipment to market. When the railroad opened, it took much of the shipping business away from these ports, but Willis Wharf continued as an important seafood production community, as it is today. This is the Walker Brothers packinghouse in Willis Wharf, c.1925. (Courtesy of authors.)

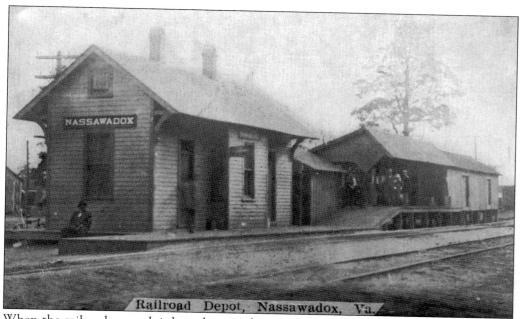

Railroad Depot, Nassawadox, Va.

When the railroad opened, it brought growth to towns and depots located along the route, and it took business away from nearby commercial wharves. The Nassawadox depot, shown here, supplanted Thomas' Wharf as the main shipping point of the area. Route 13 also bisected Nassawadox in the 1930s, making it one of the busiest communities in Northampton. (Courtesy of Carl Bundick.)

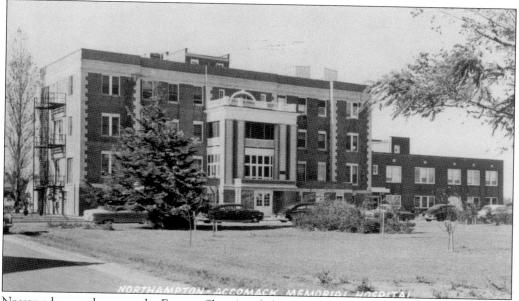

Nassawadox was home to the Eastern Shore's only hospital. Northampton-Accomack Memorial opened on August 17, 1928, after years of fundraising and work by a bi-county ladies auxiliary headed by Bessie B. Anderson, whose husband died during a trip to Baltimore for surgery. The hospital served both counties until 1972, when the original building was replaced by the current one, now known as Riverside Shore Memorial. (Courtesy of Dave Scanlan.)

Post Office, Nassawadox, Va.

The Nassawadox post office was located in the main shopping area of town just west of the railroad station and north of the lumber mill. The name Nassawadox, or Nussawattocks, originally referred to the area southwest of town near Hungar's Church, today known as Bridgetown. When the rail depot and post office were established, the station was given the name Nassawadox. (Courtesy of Dave Scanlan.)

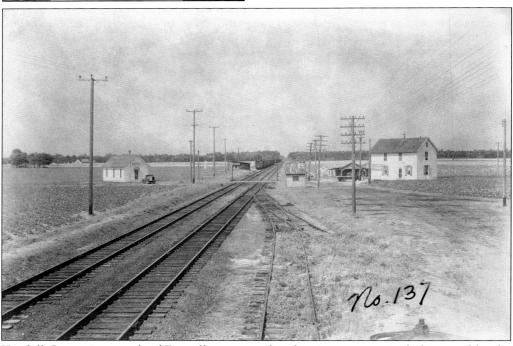

Kendall Grove, just north of Eastville, was another farming community hub created by the railroad, a place where a county road, Route 630, intersected with the railroad track. When this photograph was taken in June 1930, shipping crates were being manufactured in the low building on the right of the tracks. The two-story building housed the H. P. James "Standard" station and store. A Coca-Cola sign hangs above the front door. (Courtesy of authors.)

CANDLELIGHT LODGE
Birds Nest, Virginia

The Candlelight Lodge was one of the early motels to locate along Route 13 in Northampton. It was just south of the Bird's Nest intersection on the west side of the highway. It included cottage-style rooms similar to those at Whispering Pines and The Owl in Accomack County, as well as a restaurant. The restaurant continued to be a favorite dining spot of travelers and local people alike after the motel portion of the business closed. (Courtesy of authors.)

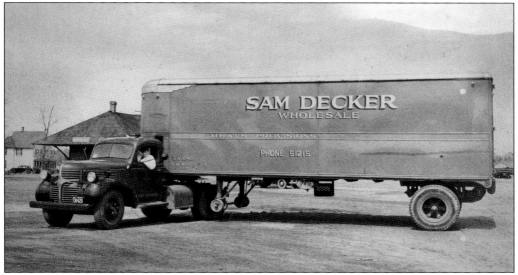

Bird's Nest was another railroad community that served local farmers and residents. The Sam Decker truck shown here was probably delivering goods to the railroad station, pictured in the background. In the first half of the 20th century, Bird's Nest had a high school, post office, barrel-making house, and numerous shops and stores. The town was named after a nearby tavern called Bird's Nest, which later became a private residence called Three Story. (Courtesy of Dave Scanlan.)

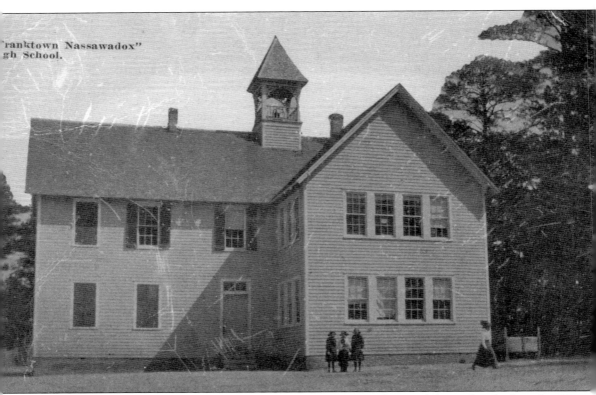

"ranktown Nassawadox"
gh School.

The Franktown-Nassawadox High School opened in 1905 and merged the student bodies of two smaller community schools. Floyd Kurtz, editor of the *Eastern Shore Herald* in Eastville, visited the school shortly after it opened and wrote glowingly of this institution of about 100 students. "It is to be hoped that the parents will not deprive their children of the splendid advantages they enjoy until and except where it becomes absolutely essential for the wellbeing of the family," he said. The principal of the school was O. L. McMath, assisted by Margaret Wescott and Miss Duncan. Carrie Watts of Franktown was the music teacher. (Courtesy of Carl Bundick.)

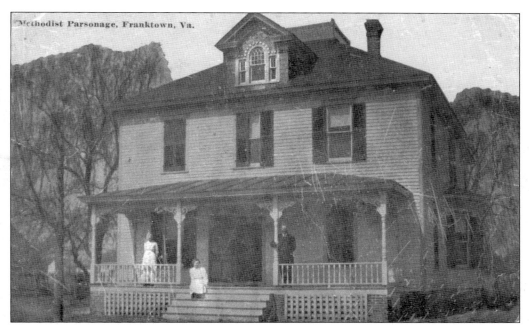

The Methodist preacher lived in this parsonage in Franktown around 1900. Franktown is one of the earlier towns in the county and was located on the bayside stagecoach line. Prior to the railroad, people tended to live in small communities such as Franktown, Bridgetown, and Johnsontown. Franktown and Bridgetown had post offices in 1840, two of only 13 towns on the Eastern Shore to be so fortunate. (Courtesy of Carl Bundick.)

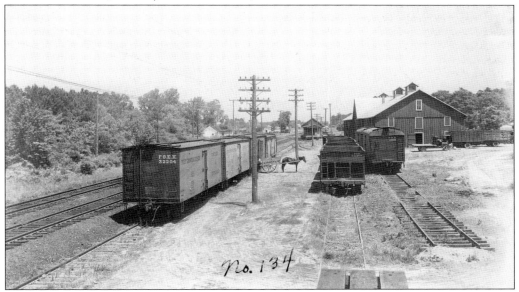

The Bayview Station was just south of the Cheriton Station and served as the railroad hub for that community. In this June 1930 photograph, produce—probably barrels of potatoes—was being loaded into a Fruit Growers Express boxcar from a horse-drawn wagon. Cheriton was originally called Sunnyside until the railroad came through. The name Cheriton is said to have been suggested by Dr. William S. Stoakley, who practiced medicine in the town. (Courtesy of authors.)

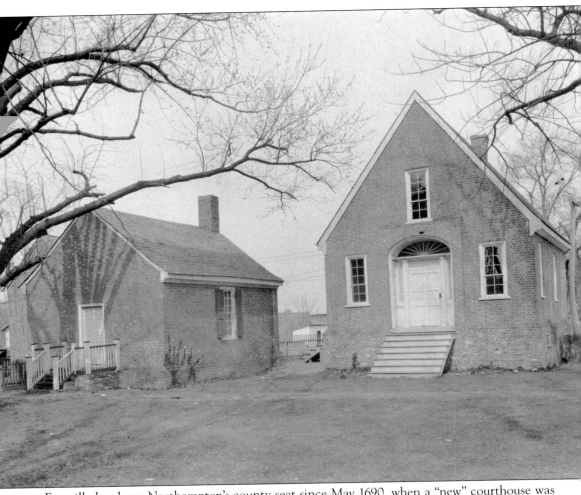

Eastville has been Northampton's county seat since May 1690, when a "new" courthouse was built to replace one farther south at Town Fields. The court has the oldest continuous court records in America. While Cape Charles and Exmore have been Northampton's primary centers of commerce, Eastville is rich in history. In August 1776, the Declaration of Independence was read from the steps of the courthouse, shown here at right. Prior to the railroad, Eastville was one of the more populous communities in the county. An 1835 state report said the town had a population of 217, and in addition to the court buildings, there were four stores, two taverns, one new Episcopal Church, and three factories manufacturing castor oil. (Courtesy of CCHS.)

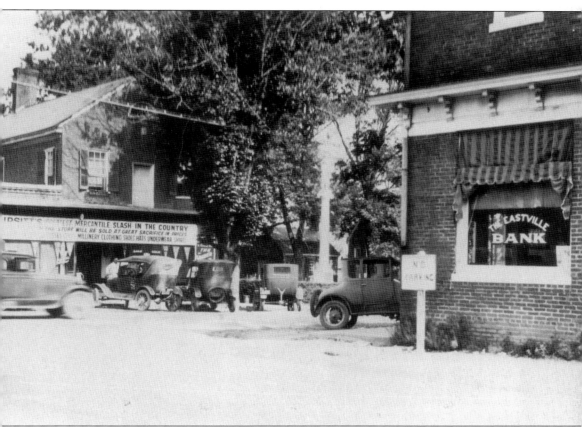

As the railroad did in other towns, the court brought people to Eastville, most of whom arrived on the train at Eastville Station, about a mile east of the courthouse. The Eastville Bank was on the corner across from the court complex, and Eastville Inn, next door to the courthouse, began serving meals and housing guests in the late 1700s. (Courtesy of authors.)

Nearly every community in Northampton had at least one store where customers could buy everything from a can of sardines to a gallon of kerosene. It was difficult to travel the back roads of the county without coming upon a friendly and well-stocked country store every few miles. This particular one was Greene's Store, in the community of Fairview, near Cheriton. (Photograph by Ted Ward; courtesy Ed Beyersdorfer.)

Perhaps the most "oft told tale" of Northampton involves John Custis IV and his wife, Frances Parke, who had a tumultuous relationship. Custis reportedly drove his horse and buggy into the Chesapeake Bay with Frances at his side. "Where do you think you are going, sir?" she asked. "To hell, lady," he replied. "Then drive on, sir," she said. Custis is buried in this cemetery at the site of his plantation, Arlington. (Courtesy of Dave Scanlan.)

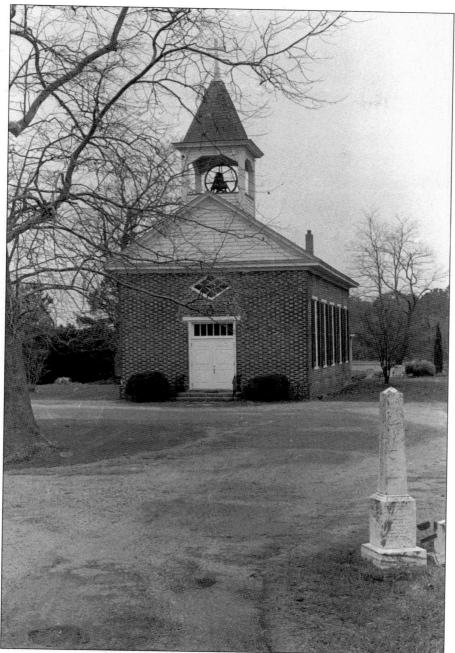

Hungars Church in Bridgetown was built during the late 1740s and was said to have had one of the first pipe organs in colonial America. The organ was destroyed after the Revolutionary War, but the church still has a silver communion set donated in 1742 by John Custis IV of Arlington. The communion set includes a chalice, paten, flagon, and an alms basin. All are engraved with the date and name of the donor. Custis and his wife had two children, one of whom, Daniel Parke Custis, married Martha Dandridge in 1749. After Daniel's death, Martha married George Washington, who became the first American president. (Courtesy of authors.)

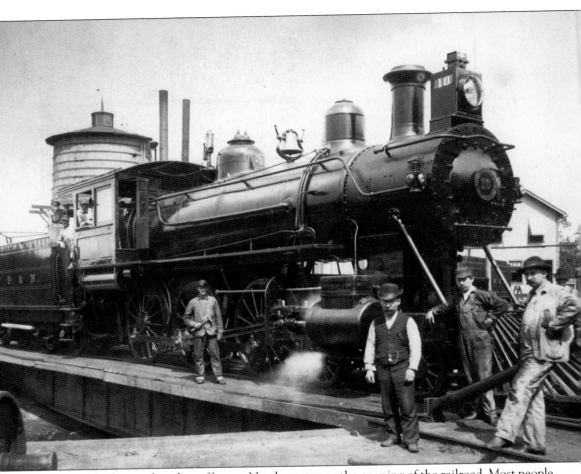

No event had so profound an effect on Northampton as the opening of the railroad. Most people lived in small communities prior to the railroad, but within a few years Cape Charles went from woods and marsh to a city of more than 1,000 people. This Baldwin locomotive was one of the first to operate out of Cape Charles. Jesse W. Oren, foreground in derby hat, was shop foreman. (Nut Redden collection; courtesy of CCHS.)

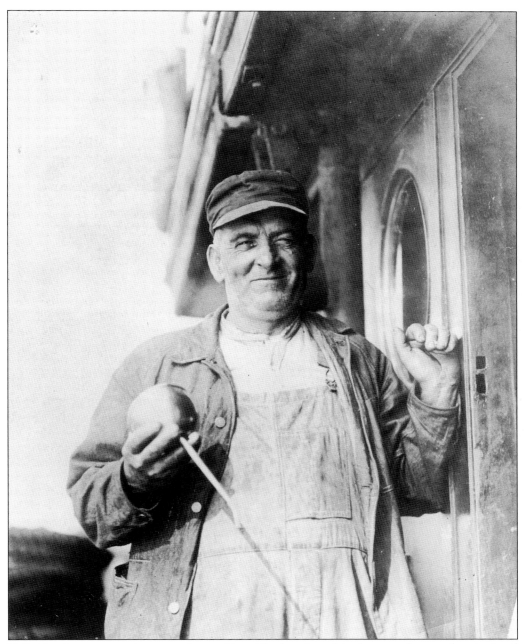

B. R. Custis was an engineer on the tug *Cape Charles* when this photograph was taken in April 1925. The *Cape Charles* was one of the busiest tugs in the railroad fleet, making more than 100 crossings a month with barge in tow. In the mid-1920s, record volumes of freight were shipped between Cape Charles and Port Norfolk—259,053 rail cars made the crossing, many of them loaded with potatoes grown on the Eastern Shore, in 1923. The town of Cape Charles grew tremendously during that period. The population increased from around 1,000 in 1900 to more than 2,500 when this picture was taken. (Nut Redden collection; courtesy of CCHS.)

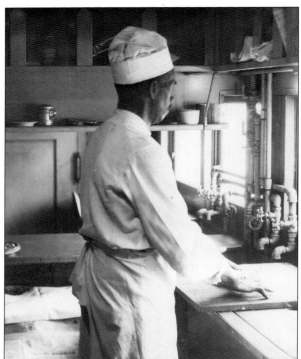

Travel aboard the NYP&N Railroad was intended to be an enjoyable experience, not just a means of getting from one place to another. Chef Parker, shown here, was known among regular travelers for his excellent pies. The food served in the dining car, and on the steamboats as well, was fresh and usually prepared onboard. (Nut Redden collection; courtesy of CCHS.)

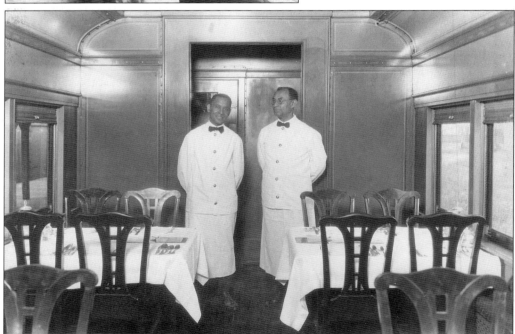

Two unidentified stewards were photographed in the NYP&N dining car around 1920. The linen tablecloths and elaborate place settings were luxurious trappings not often experienced in travel today. Modern air travel may be faster, but it lacks the grace and unhurried luxury of an earlier era. (Nut Redden collection; courtesy of CCHS.)

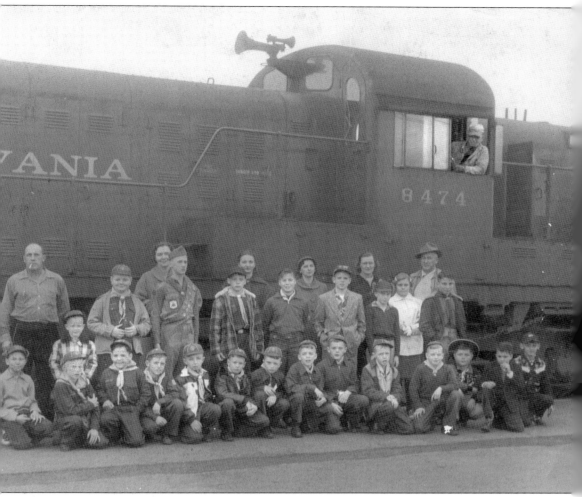

By the 1950s, train travel had given way to the automobile, and for young people who did not experience the golden age of the railroad, it was something of a curiosity. Here a group of Boy Scouts and Cub Scouts from Troop 313 in Onancock prepare to board a passenger train in Cape Charles for an excursion north to Tasley. For most of the scouts, it was their first and final trip on a passenger train on the Eastern Shore. Passenger service ended in 1958. Coauthor Curtis Badger is on the first row, sixth from right. (Courtesy of authors.)

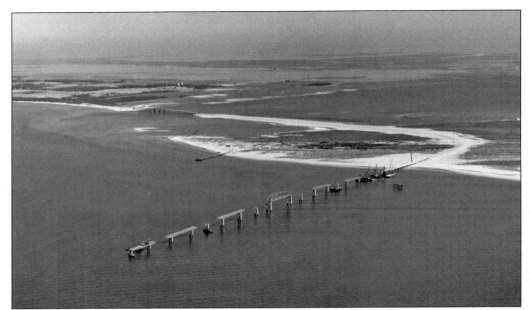

While the railroad changed the way people traveled in Northampton when it opened in 1884, construction of the Chesapeake Bay Bridge-Tunnel made travel faster and more efficient. The first piling for the bridge-tunnel was driven on October 26, 1960, and it opened for traffic in April 1964. Here the North Channel Bridge was just put in place near Fisherman Island. (Courtesy of CBB-T.)

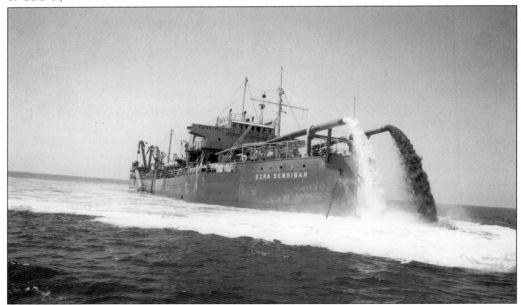

The bridge-tunnel was designed to have two tunnels to allow ships to pass. To do this, two man-made islands were constructed to anchor each end of the tunnels. Here the dredge *Ezra Sensibar* pumps sand to build an 8-acre island. Deep U-shaped trenches were dredged between the islands to accommodate prefabricated tunnel tubes. The tubes were made in Orange, Texas, and barged 1,684 miles to Virginia. (Courtesy of CBB-T.)

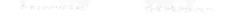

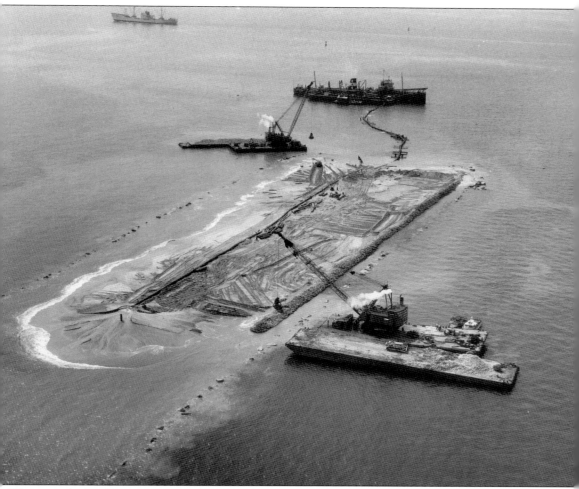

The tunnel island begins to take shape in this photograph. Sand has been dredged from the bottom to create the island, and barges loaded with armor stone are anchored along the edges. Cranes mounted on the barges move the stone to build a wall along the periphery of the island. It was daunting work, often done in adverse weather conditions. The Ash Wednesday storm hit during construction in March 1962, damaging one of the islands as it was being built. As a result, one of the tunnels is slightly longer than the other. (Courtesy of CCB-T.)

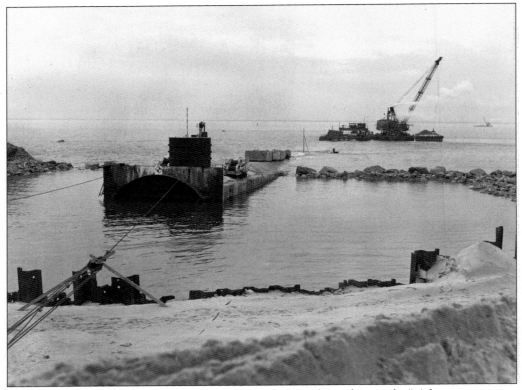

Each tunnel tube is 286 feet long and is comprised of "a tube within a tube." After construction in Texas, bulkheads were attached at each end, concrete was added for ballast, and the tubes were towed to a staging area in Norfolk, then to the work site. More concrete was added to create negative buoyancy, and the tubes were then lowered into place and attached by divers. (Courtesy of CBB-T.)

The riprap is in place, the tubes are installed, and the surface of the island is being graded. The piles, manufactured at Bayshore Concrete in Cape Charles, have been driven into position using a giant pile driver called the "Big D." The Big D was a floating platform that was anchored in place and then jacked up to become stationary as it drove piles. (Courtesy of CBB-T.)

Before the tubes were taken to the tunnel site, they were outfitted at the Sewell's Point staging yard in Norfolk. The interior of each tunnel was lined with solid concrete and fitted with a roadway slab. Each was fitted with pipelines, conduits, ventilation ducts and flues, and electrical boxes and outlets. The tubes were then resealed, suspended between two barges, and floated to the site. (Courtesy of CBB-T.)

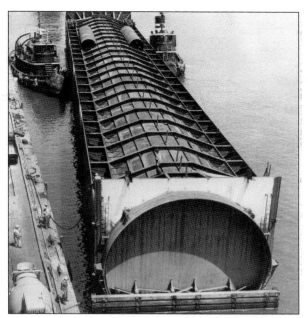

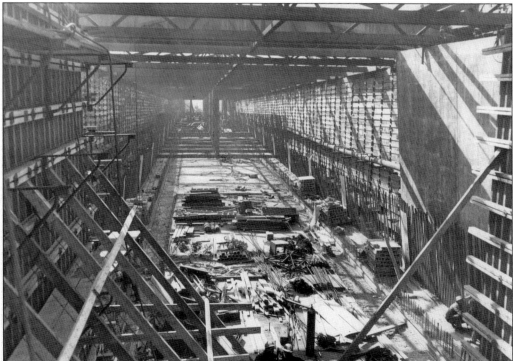

Once the tubes were secured and sealed, workmen began finishing the interior. Workers and equipment entered and exited the sunken tubes through a 9-foot-wide "snorkel hatch." Each tunnel has two large ventilation buildings at each end that pump fresh air into ducts beneath the roadway and exhaust stale air through the ceiling. This photograph was taken inside the tube, looking toward the exit ramp. (Courtesy of CBB-T.)

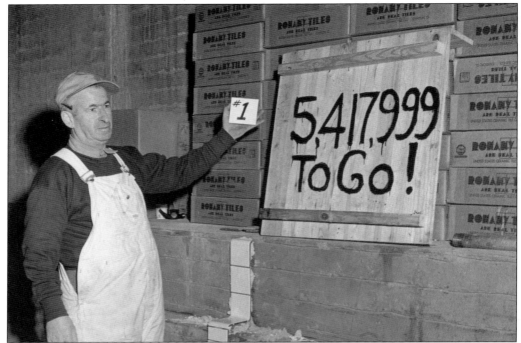

The tunnels are lined with ceramic tiles, similar to those used in a bathroom or kitchen. But in this case, millions of them were required and each was installed one at a time. This tile worker poses with "Tile No. 1" in a photograph most likely taken for a news release on the progress of the construction. (Courtesy of CBB-T.)

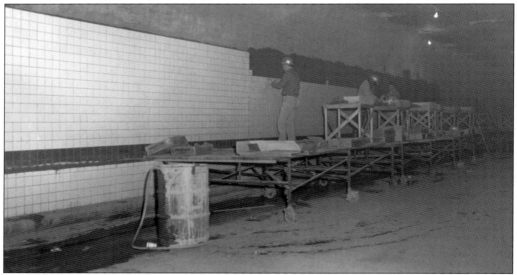

The laborious process of lining the tunnels with tiles took months. After the tunnel tubes were put into place in the trench, they were covered with a protective layer of sand and gravel. The tunnels are about 100 feet below the surface of the water and covered with about 50 feet of sand. The four islands that anchor the tubes cost about $5 million each to build, or about $625,000 an acre. (Courtesy of CBB-T.)

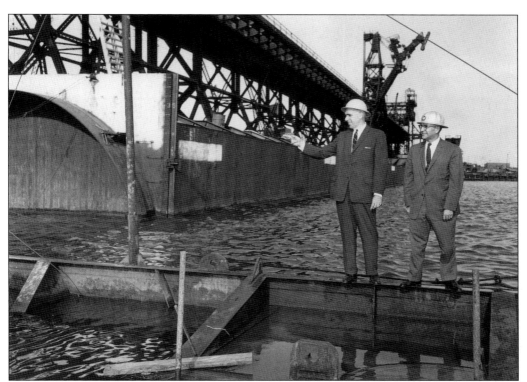

Inspecting the tunnel tubes are two men instrumental in creating and carrying out the bridge-tunnel project. Lucius J. Kellam Jr., left, was the chairman of the Chesapeake Bay Bridge and Tunnel Commission. He was president of Kellam Distributing Company in Belle Haven and a longtime proponent of the crossing. At right is J. Clyde Morris of Newport News, the first executive director of the bridge-tunnel. (Courtesy of CBB-T.)

More than anyone, it was Lucius Kellam Jr. who was responsible for conceiving the idea of a bridge-tunnel crossing and for making it a reality. At the opening ceremony on April 15, 1964, Kellam told the crowd the span "represented the culmination of a project that has stirred the imagination of Virginians for hundreds of years, and excited the interest of the world." The bridge-tunnel was named in Kellam's honor in a ceremony on October 23, 1987. (Courtesy of CCHS.)

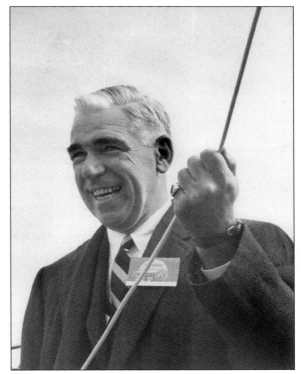

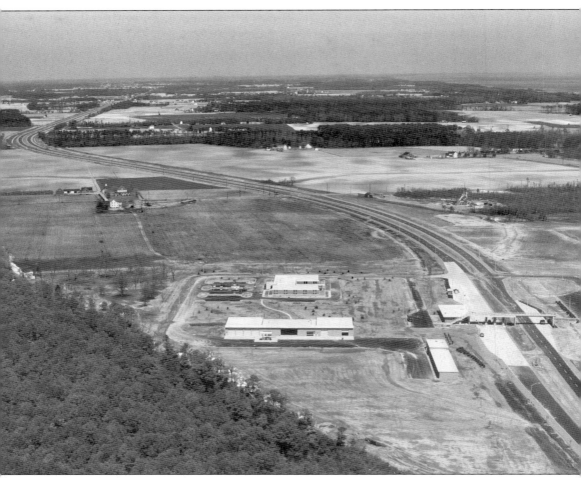

This is the north toll plaza near the time of the opening in 1964. The toll plaza is at right. The large building is the maintenance building, and the administration building is in the background. The facility is at Wise Point, the site of a large mansion once owned by the Wise family, formerly known as the Hallett Place or Cape Farm. Capt. Hugh Wise bought the property at an auction in 1902 from a group of New York men that included John S. Wise. The group had used the property as a club, and Hugh Wise purchased it for $7,000. (Courtesy of CBB-T.)

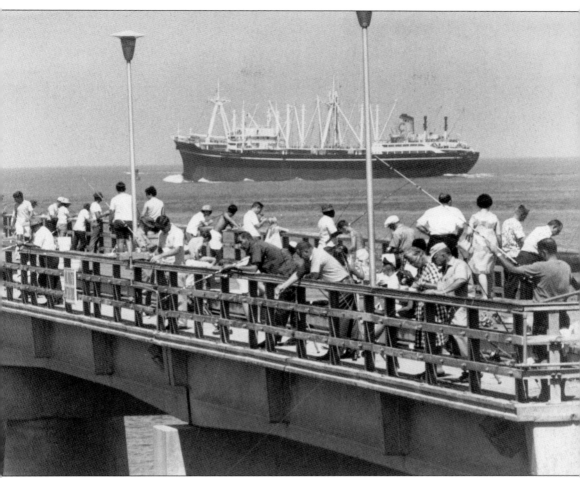

The bridge-tunnel has been more than an engineering marvel and a convenient means of north-south travel. Planners had the foresight to build a fishing pier and restaurant, making the bridge-tunnel a popular stop with an incredible view. Nowhere else can a person spend the day fishing in the middle of the Chesapeake Bay for the price of the bridge-tunnel toll. An unintended consequence of the bridge-tunnel is that the tunnel islands became a great fish magnet. The rocky shore is the perfect home for small fish and shellfish, which in turn attract large fish. The bridge-tunnel has become known as one of the best recreational fishing areas in the east, with outstanding catches of flounder and striped bass. It also has become popular among birdwatchers, who come in winter to see rare sea birds and great rafts of ducks. (Courtesy of CBB-T.)

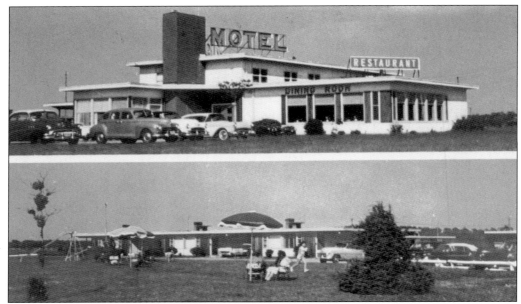

These two photographs show two generations of accommodations associated with travel. This is the Tourinns Motel and Restaurant, which stood on a hill just east of the Kiptopeke Ferry Terminal. When the bridge-tunnel opened in 1964, business suffered, as many travelers passed by a short distance away on U.S. 13. Today the site is part of Kiptopeke State Park. (Courtesy of Carl Bundick.)

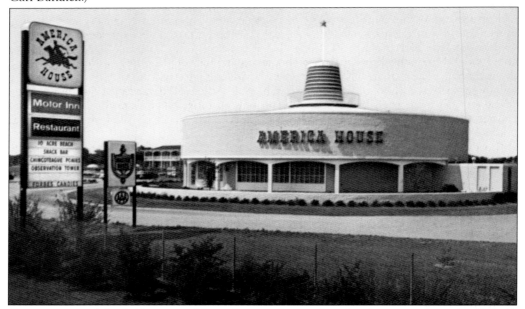

Construction of the bridge-tunnel brought speculation that development along the U.S. 13 corridor would be extensive. Route 13 was widened to four lanes and bypasses were built around several towns, but the development that was foreseen has been more a matter of evolution than revolution. One of the first motels associated with the bridge-tunnel was the America House, just north of the toll plaza. It is now Sunset Beach Inn. (Courtesy of Dave Scanlan.)

Three

AN ISLAND LIFE

There is something magical about an island: a bit of land surrounded by water, its boundaries visibly defined, access limited to only those willing to brave the sea. Islands make up a special part of Northampton County's past. People once lived on islands in the county. There were homes and stores, schools and churches, lighthouses, and lifesaving stations. These are gone now, taking with them a part of the county's past that can never return. This part of the area's past exists only in memories for an aging few and in photographs for those who did not experience it.

Hog Island is a barrier island that fronts the Atlantic east of Exmore and Nassawadox. There once was a village called Broadwater here, home to some 100 people. Other barrier islands along the coast had a few settlements, hunting clubs, and lifesaving stations, but Hog Island had the only proper town, with its own school, church, and post office. Not surprisingly, most of the island families made their living catching and selling things taken from the water: fish and crabs in the summer, oysters in the winter, and waterfowl when it was legal or when the law was not looking.

Broadwater's end came slowly, brought about by a steadily rising sea level in the first part of the 20th century, punctuated by an intense hurricane late in the summer of 1933—a killer storm that not only took human lives but presaged the death of a village. People did not leave Broadwater en masse, but over the years, family by family, house by house, Hog Island residents reluctantly gave up their island home for higher ground. Some homes in seaside communities such as Oyster and Willis Wharf began their lives on a foundation in the sandy soil of Hog Island.

No one lives on the islands anymore, but a new island era has begun. The Nature Conservancy has created a sanctuary of some 40,000 acres along 13 islands in both Northampton and Accomack. The Virginia Coast Reserve has gained national recognition as one of America's Last Great Places, an unspoiled barrier island chain that represents the last of the coastal wilderness in the east. The homes and lifesaving stations are gone, but the islands are still a vibrant part of life in Northampton.

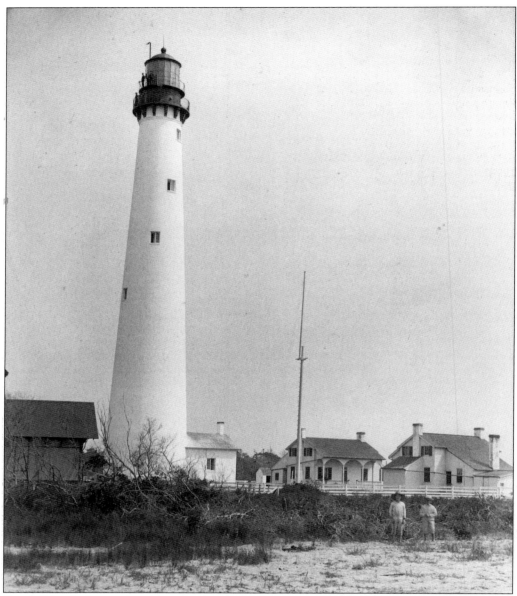

Smith Island, the southernmost in the chain of barrier islands, represents several "firsts" for Northampton. It was the first island used for salt making by Jamestown colonists, who came to gather seafood and to distill salt from seawater. It also had the first lighthouse on the entire Eastern Shore. Congress appropriated funds for the lighthouse in 1828, and it was constructed in the early 1930s. The original lighthouse was made of wood and was replaced in 1872 by this more substantial beacon. In 1871, Congress created the U.S. Lifesaving Service, and three years later a station was built on Smith, seen on the left in this photograph probably taken around 1880. Smith, strategically located near the mouth of the Chesapeake Bay, had a military presence for many years. The current lighthouse, constructed of steel, is one of the first Eastern Shore landmarks visitors see when traveling north on the bridge-tunnel. (Courtesy of Mariner's Museum, Newport News, Virginia.)

This lighthouse was built on Hog Island in 1852 and served until a steel lighthouse was erected in 1896. Like Smith Island, Hog Island also was home to the lifesaving service. A station was built there in 1876, south of the lighthouse site, and another station was added on the north end of the island some years later. (Courtesy of BIC.)

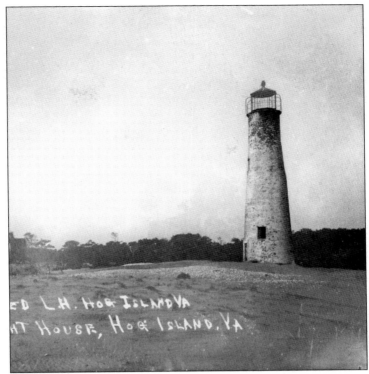

While most marine beacons today are controlled by computers, lighthouses of the 19th century were high maintenance. Light was provided by oil lanterns, which meant that oil containers needed to be filled, and the reflectors had to be polished. That was the job of the lighthouse keeper, whose residence was part of the lighthouse compound. This bungalow was home for the keeper of the 1852 light. (Courtesy of authors.)

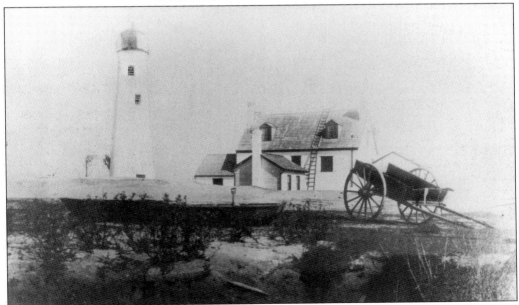

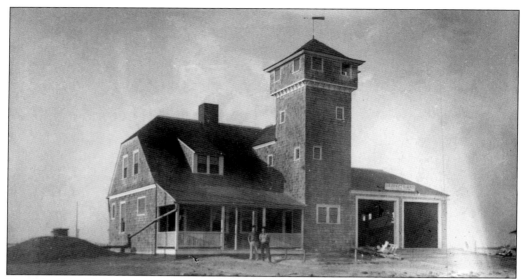

Hog Island had lifesaving stations, and later coast guard stations, on both the south and north ends of the island. This was originally a lifesaving station and later converted to a coast guard station when the coast guard was created in 1915. The building was constructed around 1876 on the south end of the island. It was extensively damaged during the storm of 1933. (Courtesy of BIC.)

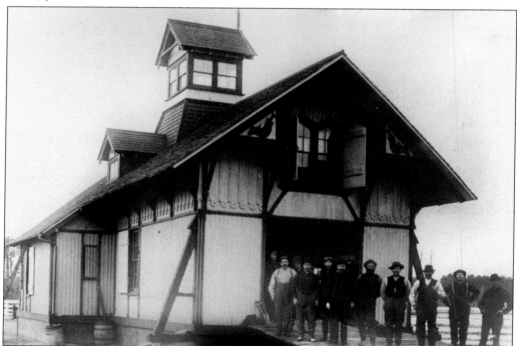

Lighthouses, and later the lifesaving service, helped save countless lives and many millions of dollars worth of property. This is an early photograph of the station on Smith Island. In the early years, service crew members dressed in civilian clothing. Later, uniforms were issued. The cupola provided a 360-degree view of nearby waters. (Courtesy of BIC.)

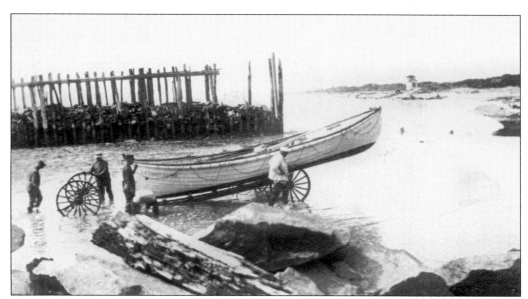

The Smith Island lifesaving crew conducts a lifeboat drill behind the breakwater built to protect the lighthouse. Working in the lifesaving service was a popular occupation on the Eastern Shore, and the captains who were in charge of each station were highly thought of in the community. Newspapers in the 1880s were filled with accounts of daring rescues that saved lives and property. (Courtesy of BIC.)

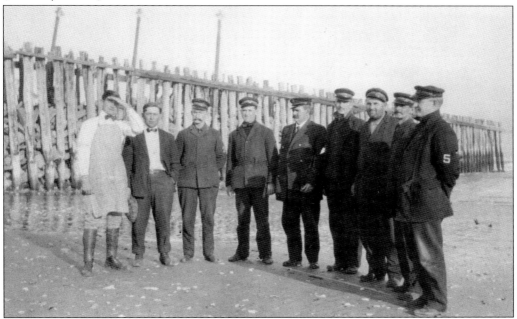

Capt. George W. Hitchins was in charge on Smith Island and is pictured in the center of this group. The *Peninsula Enterprise* published an account of a rescue in March 1888 by Hitchins and his men. Capt. Polk Lang of Accomac was aboard his sloop *Florence Killinger* when she washed ashore on Smith Island during a storm. The crew rescued the sailors and repaired the boat, and Lang continued on to Norfolk. (Courtesy of BIC.)

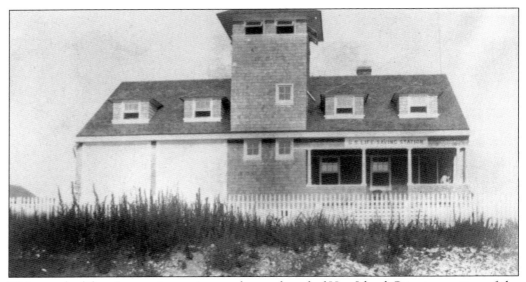

This was the lifesaving service station on the north end of Hog Island. Prior to creation of the lifesaving service, rescues were performed by local volunteers. Congress created the U.S. Lifesaving Service in 1871 as part of the Department of the Treasury. The first stations were built on the Eastern Shore in 1876. (Courtesy of authors.)

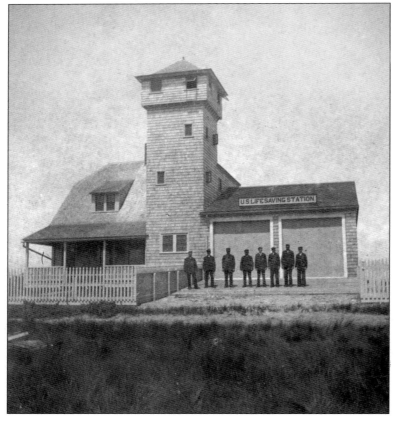

The south end of Hog Island was the location of this station. All the local stations, from Delaware Bay to the mouth of the Chesapeake Bay, were part of Lifesaving District 6. The first superintendent was Benjamin W. Rich, who was a seaman until moving to Accomack County in 1857 to take up farming. He served as superintendent until his death in 1901. (Courtesy of Carl Bundick.)

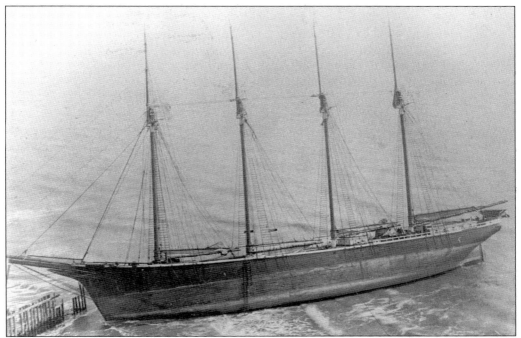

One of the more famous wrecks was that of the schooner *Massasoit*, a New England vessel on its way to Norfolk when it was battered by a northeaster in November 1914. The boat went ashore on Smith Island, and its crew was rescued by captain Hitchins and his men. Captain Haskell of the *Massasoit* presented Hitchins the ship's Bible, which is on display at the Barrier Island Center in Machipongo. (Courtesy of BIC.)

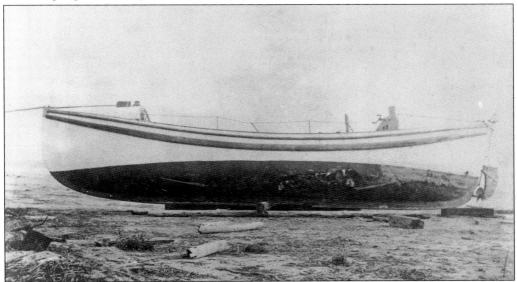

This Smith Island lifeboat was used to take the crew off the *Massasoit*. The large surf boat was self-righting and self-bailing and able to handle dangerous seas, but the crew was still exposed to the elements during rescues, which often took place during rough weather. This boat was motor-powered and kept in the boathouse at the station. (Courtesy of BIC.)

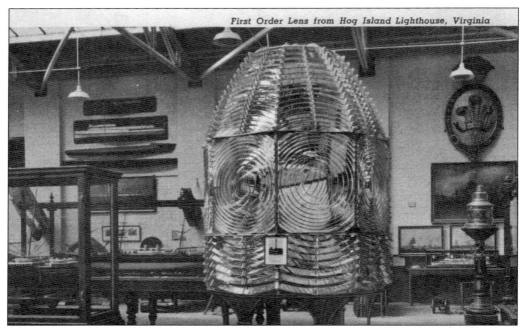

First Order Lens from Hog Island Lighthouse, Virginia

The lighthouses, lifesaving stations, and coast guard stations on Hog Island are part of Northampton County history, but reminders of life on the islands still live on. Many remain in the county in private collections or in public places such as the Barrier Island Center. This lens from the old lighthouse on Hog Island can be seen in the Mariners' Museum in Newport News, Virginia. (Courtesy of Carl Bundick.)

The coast guard station on Cobb's Island was known for its impressive third-story cupola, which afforded men on watch an expansive view of the inlet, ocean, and vast salt marshes. The station was on the south end of the island, built a short distance from an earlier lifesaving station, the remains of which still exist. (Courtesy of authors.)

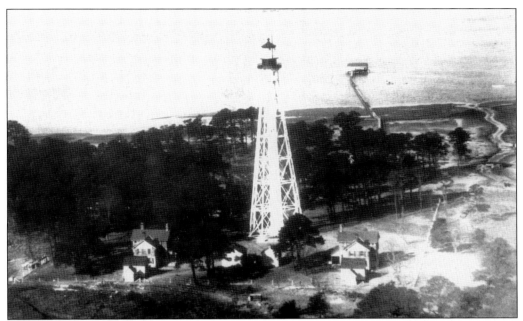

The steel Cape Charles lighthouse on Smith Island included quite a compound of satellite buildings when this photograph was taken around 1930. Buildings included a dwelling for the lighthouse keeper and his family, a boathouse and dock, and other support structures. (Courtesy of BIC.)

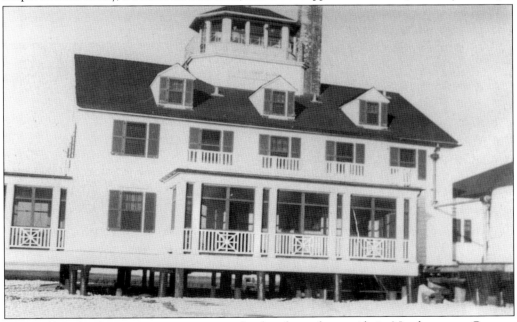

The Cobb's Island station was a prominent landmark on the seaside in Northampton County. But advances in electronic communication, radar, and aerial search made the stations outdated in the years following World War II. The Cobb's Island station was decommissioned in March 1964 and for many years sat empty and abandoned. In a dramatic move, it was loaded onto a barge and moved to a mainland site at Oyster in the spring of 1998. (Courtesy of authors.)

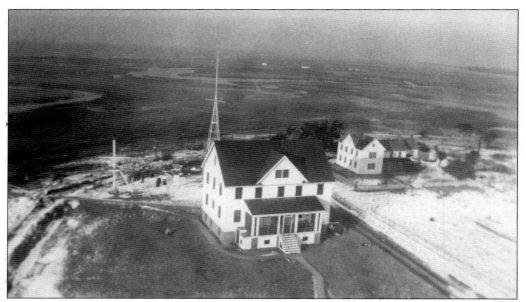

This coast guard station on the south end of Hog Island was built in the 1930s and was decommissioned in the early 1960s. It sat abandoned for many years and was destroyed by fire in 1987. Several old coast guard stations, including two on Parramore Island in Accomack County, have been destroyed by fire in recent years. (Courtesy of BIC.)

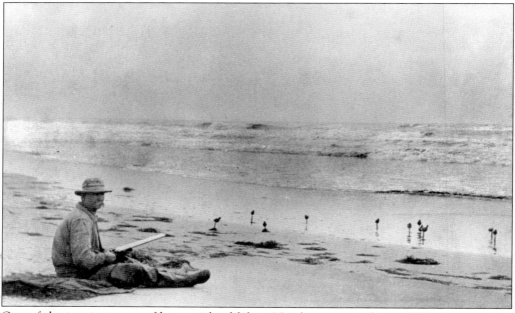

One of the iconic images of barrier island life in Northampton is this c. 1890 photograph of George Doughty, keeper of the Hog Island lighthouse, hunting shorebirds along the surf with a set of hand-carved decoys. Shorebird hunting was legal at that time and was widely practiced on the seaside. Local resorts and hunt clubs advertised spring shorebird hunting in brochures and outdoor magazines, and sportsmen arrived on the NYP&N for a few days of shooting and fishing. (Courtesy of authors.)

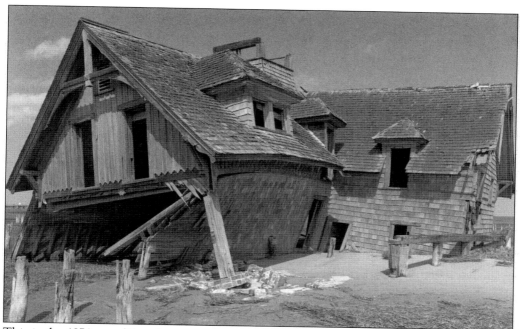

This is the 1874-type lifesaving station on Cobb's Island in a photograph taken around 1980. This was the last of the early lifesaving stations in the county. Those on Smith Island and Hog Island were taken by a rising sea level, and the sites where the stations stood are now under water. (Courtesy of authors.)

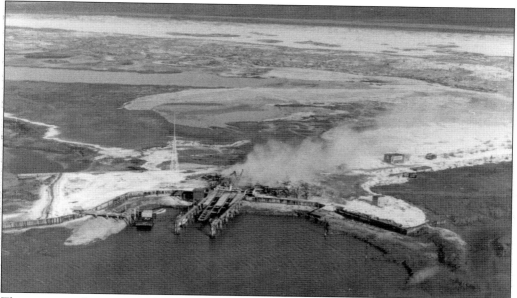

The coast guard station on the north end of Hog Island was called the Little Machipongo Inlet station, which was built in 1936 and destroyed in 1957 by a fire that began in the furnace room. The station was similar in design to the Cobb's Island station, complete with the third-story cupola. After the fire, the station was replaced by a brick building, but the station was decommissioned in 1964. (Courtesy of the authors.)

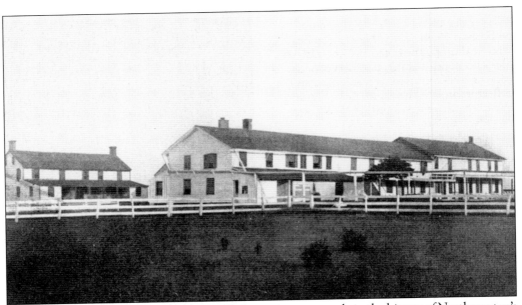

While the lifesaving service and coast guard play an important role in the history of Northampton's barrier islands, these remote beaches also drew many visitors who came for hunting, fishing, and swimming in the surf. This is the famous Cobb's Island Hotel around 1885 in a photograph from Alexander Hunter's classic *The Huntsman in the South* (Neale, 1908). (Courtesy of the authors.)

Visitors to the Cobb's Island Hotel usually took the steamboat to Cherrystone or the railroad to Cheriton Station or Cobb's Station, a coach to the seaside, and then traveled by boat to the island. The *Clara Combs*, shown here, was one of the boats used to ferry passengers to the hotel. (Courtesy of authors.)

The gentleman on the left is thought to be Nathan Cobb Sr., the New Englander who established the hotel on Cobb's Island and who began a family tradition of decoy carving well-known among museums and collectors around the world. With him is one of the three wives he had at different periods of his life. On the back of the original photograph is the inscription "for George Cobb." George was one of Nathan's grandsons. (Courtesy of BIC.)

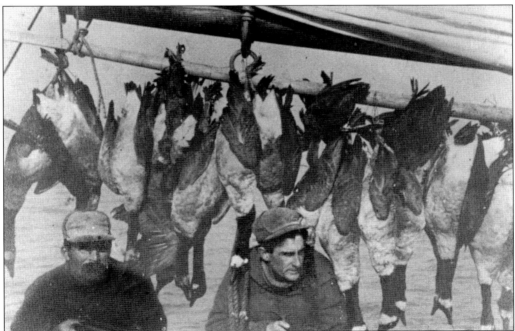

Thomas Dixon, right, was a lawyer, preacher, and controversial novelist who lived for several years in Northampton County. He is shown here hunting with guide George Isdell in a photograph from his autobiography *The Life Worth Living*, published in 1905. Dixon wrote extensively of hunting waterfowl along the coast but was best known for his racially charged novel *The Clansman*, which he later helped adapt as a screenplay for the film *The Birth of a Nation*. (Courtesy of authors.)

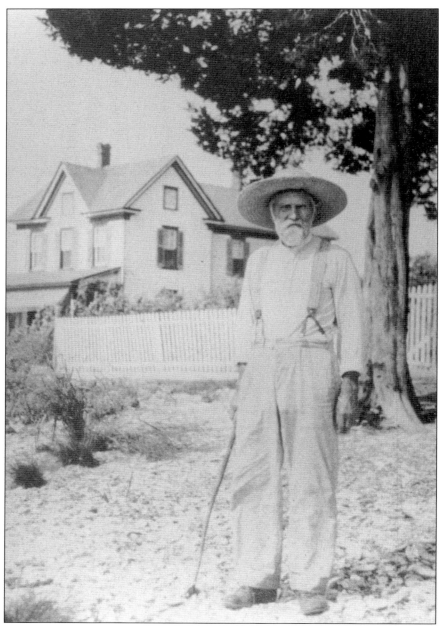

Elkanah Cobb was the son of Nathan Cobb Jr. and the grandson of Nathan Sr. The elder Cobb bought Sand Shoal Island in 1839, which soon became known as Cobb's Island. The Cobbs salvaged shipwrecks, engaged in the shipping business themselves, and eventually built a hotel and guest cottages on their island. The resort was advertised in the leading outdoor journals of the late 1800s, and when the railroad opened in 1884 it enjoyed its most prosperous years. The Cobbs today are perhaps best known for the hunting decoys they made when they were guiding visiting sportsmen. Nathan Cobb Jr. is considered the dean of the decoy makers, and the best of his work today is in museum collections of American folk art. He passed along his carving skills to Elkanah, whose work is highly sought by collectors. (Courtesy of authors.)

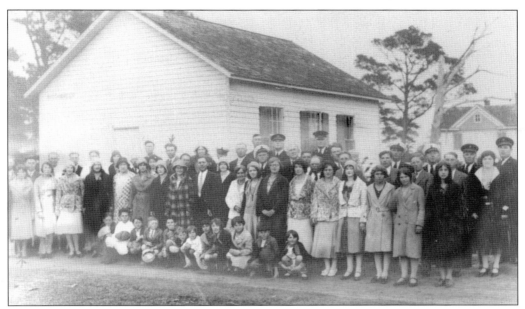

While Cobb's Island had the resort and the community that supported it, Hog Island was the only barrier island in Northampton that had an established village, complete with stores, residences, a post office, and a church. Here the congregation of Pullin's Chapel Methodist Episcopal Church poses for a group picture. The church shown here is today in the village of Oyster. (Courtesy of authors.)

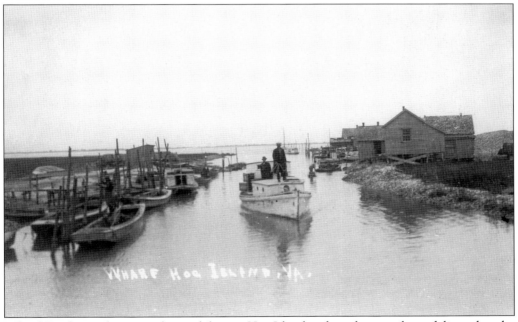

Wharf Creek was the major thoroughfare on Hog Island and was how mail was delivered to the Broadwater post office. Seafood harvesting was the main business on the island, with oysters, clams, fish, and crabs being sent to market on a daily basis when in season. After the railroad came through in 1884, nearby Exmore became a major shipping center. (Courtesy of BIC.)

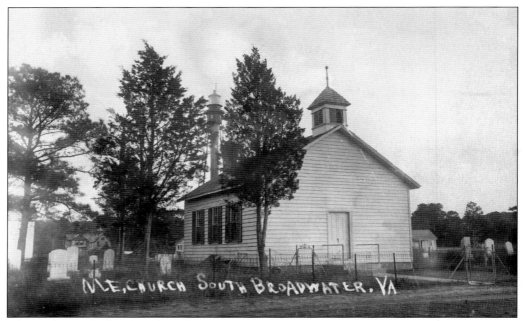

This is the Methodist church in the village of Broadwater, probably in the late 1920s. The steel lighthouse and what is most likely the Broadwater Club are in the background. The church cemetery is on the left. The building is now part of the sanctuary of Travis Chapel United Methodist Church in Oyster. The church site is now under water. (Courtesy of BIC.)

Life was usually centered around the basics on Hog Island: the wind, weather, tides, and the cycles of birds and fish that were a daily part of life. Stores offered necessities such as flour, sugar, coffee, and the occasional sweet. This was Harry Bowen's store in Broadwater around 1920. (Courtesy of BIC.)

Eli Doughty, well known hunting guide, decoy maker, and waterman, was born on Hog Island but lived his adult life in this house in Willis Wharf. Doughty hosted numerous famous guests in the house when they were on their way to a holiday at Hog Island, possibly including Pres. Grover Cleveland. The house, which overlooked Parting Creek on the site of the present post office, was dismantled in 1947. (Courtesy of BIC.)

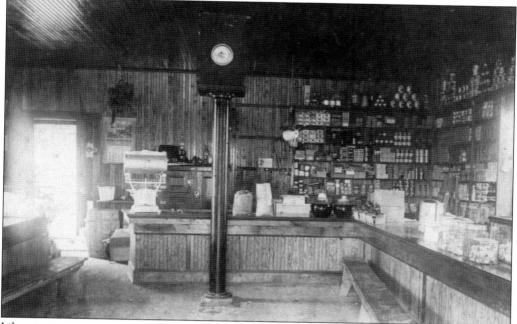

Like most country stores in Northampton, Harry Bowen's store on Hog Island featured canned goods and other staples to round out a diet heavy in seafood. It was also a community gathering place, where local residents could exchange news and the occasional bit of gossip. No one was photographed in this scene, but the wooden benches along the counters were no doubt heavily used. (Courtesy of BIC.)

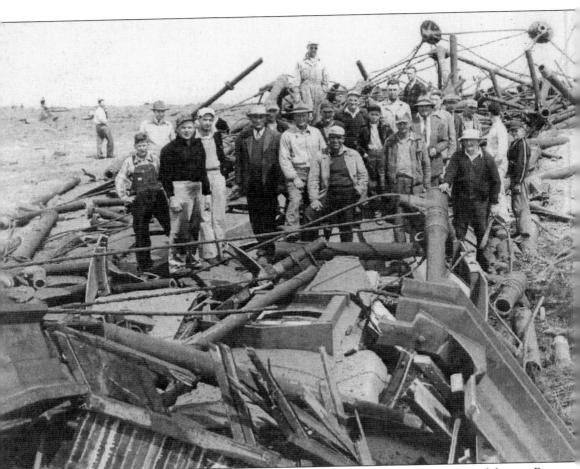

The steel lighthouse on Hog Island was built in 1896, and at the time it was state of the art. But advances in electronics and communications made many of the old lighthouses unnecessary. This lighthouse served until World War II and then was decommissioned. In this photograph, taken in 1948, a dynamite charge had just been ignited and the old light was down. Bill Russell, fourth from right in the white hat, was in charge of demolishing the 1896 lighthouse, and this is the crew that helped dismantle it. The light had been removed, and the steel parts were sold as scrap. Some pieces still remain on the island. (Courtesy of BIC.)

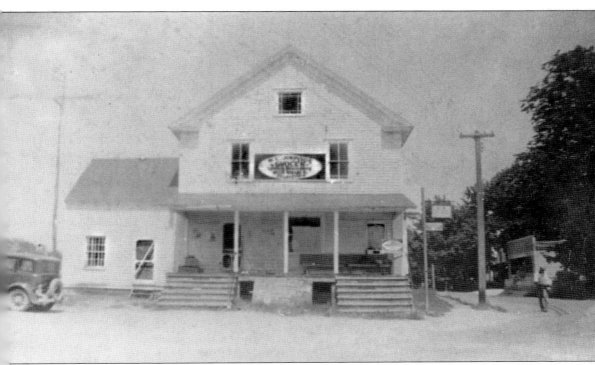

One of the better known landmarks in Willis Wharf is the E. L. Willis store, which was known as the W. E. Johnson store in 1939 when this photograph was taken. The original store was in the small structure on the left, which is believed to have been built in the 1840s. As a store, E. L. Willis offered everything from canned beans to marine hardware. After the store ceased operations, it became a popular restaurant for many years. (Courtesy of BIC.)

Life on the barrier islands was not all about seafood harvesting and the lifesaving service. For centuries, Northampton residents have seen the islands as a place for recreation. While some people lived and worked on the islands, others visited on weekends with family and friends simply to enjoy swimming in the ocean and beachcombing. These are members of the Walker family, who began a seafood processing business in Willis Wharf in 1889. (Courtesy of authors.)

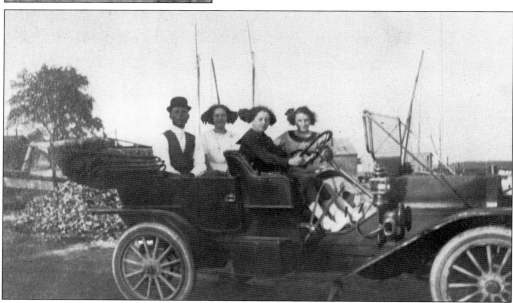

The Walkers posed for a photograph in their Model T on their way to board a boat for Hog Island. Beach gatherings in the early 1900s were a more formal occasion than they are today. Many families took a trip to the beach following church on Sunday. The gentleman in the back seat is probably William Everett Walker, who moved to Northampton from Oriole, Maryland. He was in the oyster business and later served as vice president of Northampton Lumber Company. (Courtesy of authors.)

This young couple was very fashionably attired for a c. 1920 beach picnic. In the background, swimmers enjoy the surf of Hog Island. Beach picnics and boat races were a regular part of island life in Northampton. The boat races usually were part of a large community celebration that sometimes involved several hundred people. Results of the races were reported in local newspapers. (Courtesy of authors.)

This is the busy harbor area of Willis Wharf, which during the pre-railroad days was a major shipping point for seafood and vegetable crops. Although Northampton is surrounded by water, there are few places where deep water approaches upland. Willis Wharf and nearby Thomas Wharf were two such places on the seaside. (Courtesy of authors.)

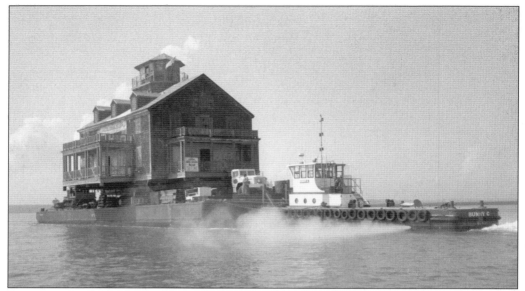

Boaters in the Cobb Island area were in for a strange sight on a May morning in 1998. The Cobb Island coast guard station had been loaded onto a barge and was towed to a mainland site near Oyster. The Nature Conservancy, which owned the island and the old station, was fearful that fire would destroy the landmark, so it was moved, restored, and is now used as a conference center. (Courtesy of authors.)

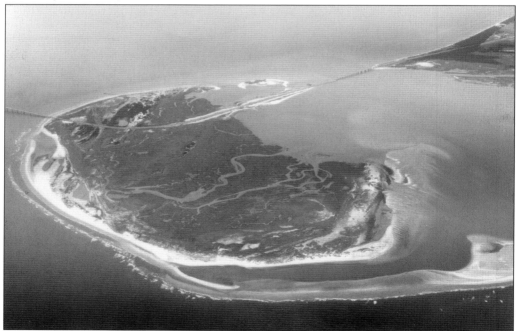

Perhaps it is fitting that the final photograph in the "Island Life" chapter is the last island in the chain that lines Northampton's coastline. This is Fisherman Island, which is crossed by the Chesapeake Bay Bridge-Tunnel. The island is a wildlife refuge, managed by neighboring Eastern Shore of Virginia National Wildlife Refuge. (Courtesy of U.S. Fish and Wildlife Service)

Four

CAPE CHARLES, THE NEW FRONTIER

Northampton County is thought of as a rural, conservative community, where change comes gradually and decisions are made with due diligence. The wheels of progress are perceived as turning slowly in Northampton, and thoughts of the future are heavily colored by reverence for the past.

Cape Charles, on the contrary, has never been that way. It was a child of the railroad, a little city born of prosperity, created in the minds of architects and planners, a community that grew to adulthood without evolving through childhood and adolescence. Early photographs of Cape Charles show the area to have been a combination of marshland, woodland, and open fields. Trees were felled to make room for houses and businesses, and timber from the trees was used to create a bulkhead and build a marina where railroad barges tied up.

Cape Charles was created when the New York, Philadelphia and Norfolk Railroad built a line down the Eastern Shore and across the bay to Norfolk. William L. Scott, a wealthy industrialist from Erie, Pennsylvania, had the vision to link the agricultural south with the industrial north by extending a rail line down the peninsula and across the Chesapeake Bay by barge. Scott bought more than 2,100 acres between King's Creek and Old Plantation Creek, and in 1884 he leased land to the railroad for a terminus and port. He laid out 136 acres north of the port and designed the town of Cape Charles.

The railroad and ferries began making their runs in late 1884, and within a year Cape Charles looked like a gold rush boomtown. The three decades between 1900 and the Great Depression were extremely prosperous for Cape Charles, which quickly became the economic center of the lower Eastern Shore. The boom lasted until the popularity of highway transportation gradually ended passenger rail travel and the ferry terminal was moved a few miles farther south to Kiptopeke.

Cape Charles today has reinvented itself as a vacation and golf resort. A century after William L. Scott laid out the streets of Cape Charles City, Richard "Dickie" Foster of Virginia Beach created the Bay Creek resort on land that Scott earlier purchased. The ferries no longer run, but the new marina is lively with boat traffic and the two new courses are getting national attention among golfers.

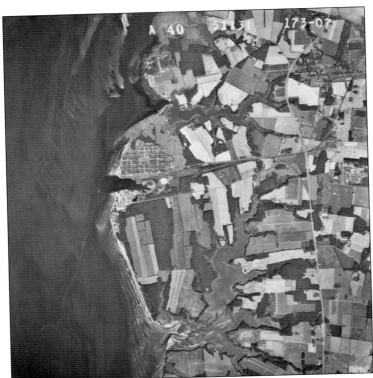

This 1974 aerial photograph shows the town of Cape Charles and the expanse of land purchased by William L. Scott. In 1883, Scott bought three tracts of land for $55,000 from the Tazewell family, totaling more than 2,100 acres. The property was bordered by King's Creek on the north, just above the town in this photograph, and by Plantation Creek on the south, near the bottom of this photograph. (Courtesy of CCHS.)

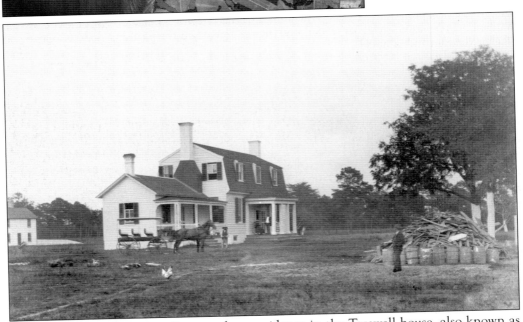

After purchasing the estate, Scott took up residence in the Tazewell house, also known as Hollywood. Over the next few years, he built many additions to the house, creating a lavish home out of the formerly simply structure. He threw extravagant parties, entertaining dignitaries such as Gov. Fitzhugh Lee in 1883 and Pres. Grover Cleveland in 1886. This photograph shows the house around 1885. (Courtesy of Hagley Museum and Library.)

98

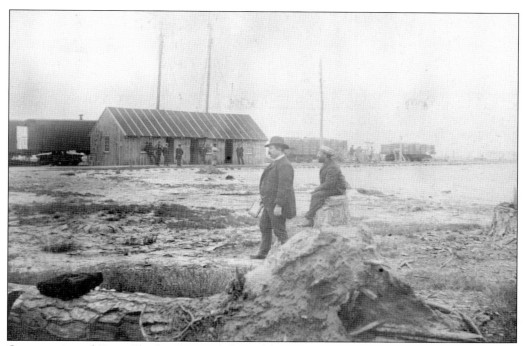

Construction of Cape Charles City and the rail line terminus was well under way by the time this photograph was taken on June 1, 1885. The first passenger station at Cape Charles can be seen in the background. The well-dressed man in the foreground may be Alexander Cassatt, William Scott's business partner in building the rail line down the Eastern Shore. (Courtesy of Hagley Museum and Library.)

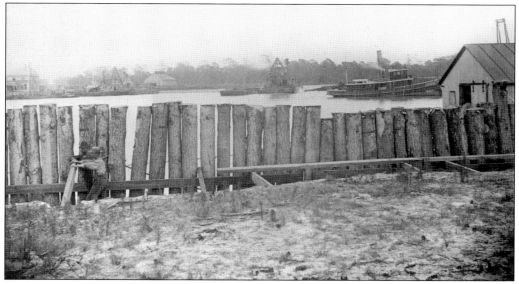

Workers can be seen building the bulkhead for the harbor in this June 1885 photograph. The trees that were cut down to make room for the railroad buildings and the town itself were not wasted—they were turned into lumber or used to make the above bulkheads. (Courtesy of Hagley Museum and Library.)

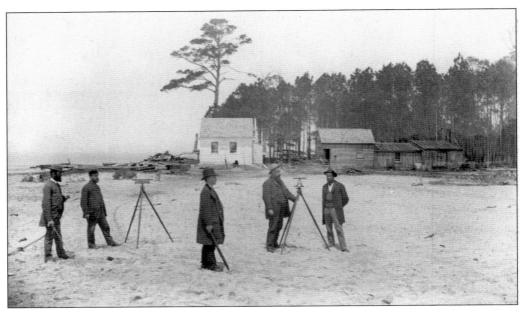

The men in this May 1885 photograph made up the engineer's office for the NYP&N at Cape Charles. Alexander Cassatt, a skilled engineer as well as financial backer for the project, selected the path of the railroad, as well as the southern terminus. Rather than use the already established port of Cherrystone, he chose the site that would soon become Cape Charles City due to its proximity to a deep channel. (Courtesy of Hagley Museum and Library.)

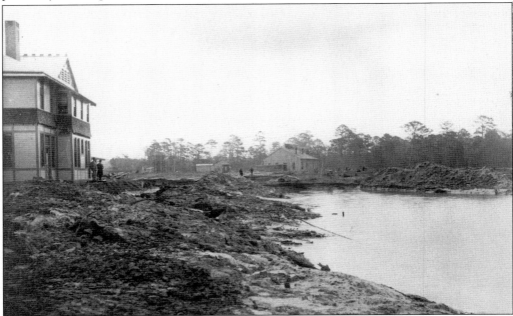

Taken on May 9, 1885, this photograph shows Mud Creek in the middle of its transformation into a deep harbor. When Cassatt chose this site for the harbor it was little more than a muddy tidal pond, filling with water only at high tide. However, Cassatt knew deep water was less than a quarter of a mile away. (Courtesy of Hagley Museum and Library.)

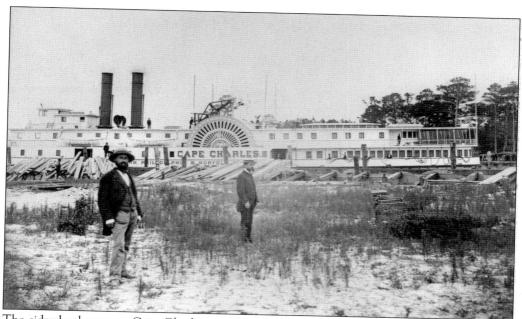

The sidewheel steamer *Cape Charles* was the first ship purchased by the NYP&N to operate between Cape Charles City and the western side of the bay. The *Cape Charles* was an unusual vessel. It was capable of carrying passengers but also had railroad tracks with room for four sleeping cars. Unfortunately the passenger service was not as popular as expected and the ship was sold to New York in 1888. (Courtesy of Hagley Museum and Library.)

When William Scott purchased the Tazewell estate, he knew quite well a town was needed at the rail terminus. In 1884, Scott had 136 acres just north of the harbor surveyed, mapped, and subdivided. Along with a central park, 644 building lots were laid out for development. Pictured here is the east end of Cassatt's Row, looking north on Tazewell Avenue, in late May 1886. (Courtesy of Hagley Museum and Library.)

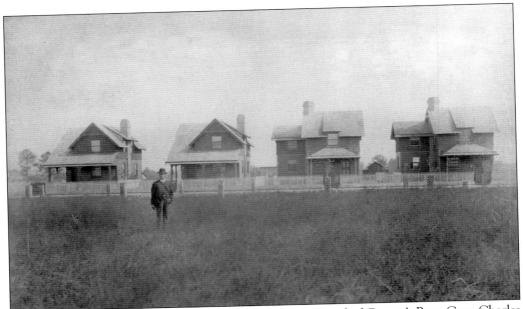

This photograph, also taken in May 1886, shows the west end of Cassatt's Row. Cape Charles City was laid out with seven east-to-west avenues and six north-to-south streets. The avenues were named Mason, Randolph, Tazewell, Monroe, Madison, Jefferson, and Washington after prominent Virginians. The streets were named Pine, Strawberry, Peach, Plum, Nectarine, and Fig. (Courtesy of Hagley Museum and Library.)

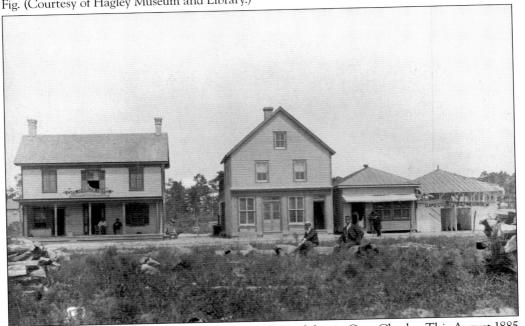

Mason Avenue has always been the commercial thoroughfare in Cape Charles. This August 1885 photograph shows the Cape Charles Hotel on the left. The third building from the left was the mayor's office, and the building on the right was the lunchroom, presumably for workers building the town and railroad. (Courtesy of Hagley Museum and Library.)

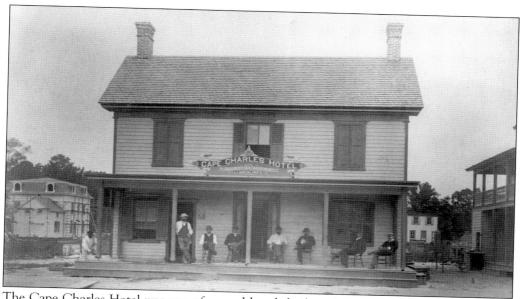

The Cape Charles Hotel was one of several hotels built early on. Littleton Sturgis built the hotel in 1883 on railroad property, but it was later moved to Mason Avenue. It had four rooms, with an add-on kitchen. By the time this photograph was taken on August 28, 1885, the hotel had been sold to property speculator J. J. Bunting. He had a short stay in Cape Charles, as he was imprisoned after having his own property burned to collect insurance. (Courtesy of Hagley Museum and Library.)

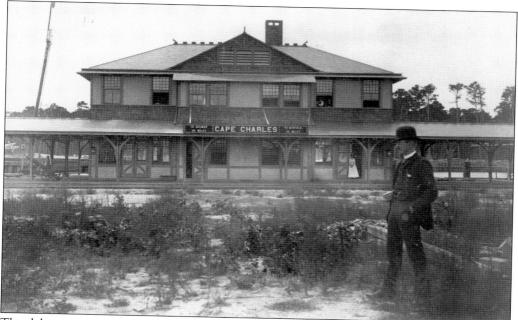

The elaborate passenger station at Cape Charles had recently been completed in this August 1885 photograph. It was at this point that southbound passengers transitioned from rail travel to traverse the 36-mile stretch to Norfolk by steamer. This building housed the NYP&N superintendent's office as well. (Courtesy of Hagley Museum and Library.)

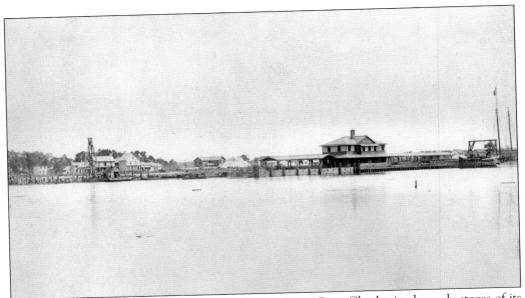

This 1885 view of the harbor from the south side shows Cape Charles in the early stages of its rapid growth. The large passenger terminal is on the right, with Mason Avenue running east-to-west behind it. The Cape Charles Hotel is visible on the left side of the photograph. In just a few short years, the town blossomed into a buzzing commercial center. (Courtesy of Hagley Museum and Library.)

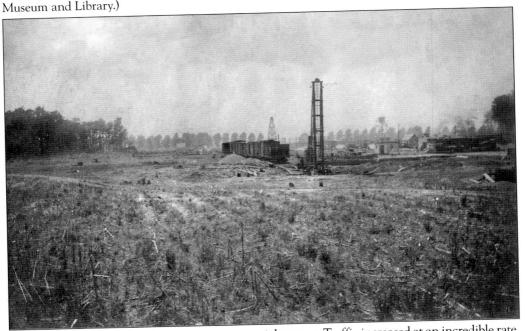

By all accounts, the railroad was a great commercial success. Traffic increased at an incredible rate, and by 1910 the buildings at the yard in Cape Charles were due to be upgraded. The Pennsylvania Railroad, which bought the NYP&N in 1908, invested vast sums of money to fund construction at Cape Charles. The building of a new machine and erecting shop had recently begun in this photograph, taken May 16, 1910. (Nut Redden collection; courtesy of CCHS.)

The NYP&N's first electric power plant came online on October 11, 1904, lighting all offices, shops, docks, and yards with a brilliant electric glow. The significant expansion necessitated the building of a larger power plant, seen here under construction on August 27, 1910. The new station also provided some power to the town of Cape Charles. (Nut Redden collection; courtesy of CCHS.)

Construction on the new shops was progressing well by September 1910. The new, 75-foot turntable was surrounded by state-of-the-art machine shops. With the new shops, NYP&N was able to repair its own railcars and locomotives. The new power plant allowed workers to make repairs 24 hours a day, keeping railroad operations running smoothly. (Nut Redden collection; courtesy of CCHS.)

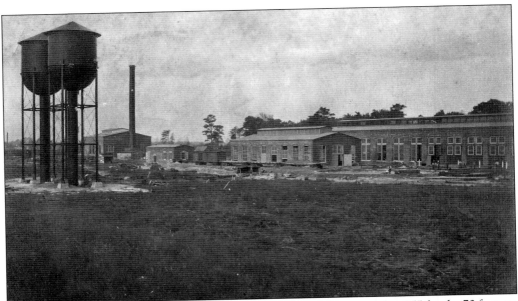

The new construction included the machine and erecting shop, measuring 255 feet by 70 feet; an engine house with six tracks; a boiler and flue shop measuring 100 feet by 50 feet; a new office building; and several other structures. All of the new buildings were heated by steam and well lit, powered by the new power plant, visible on the left side of this photograph. Construction was completed in 1911. (Nut Redden collection; courtesy of CCHS.)

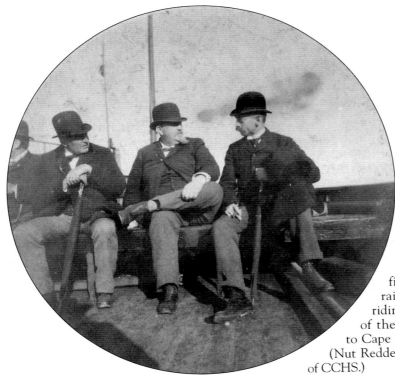

Jonathan Keller, left, was contracted to build the line from the Pocomoke River to Cape Charles. The man in the middle is likely Cpt. Orris A. Browne. The man on the right is a Mr. Strong from Erie, Pennsylvania, likely a financial backer of the railroad. These men are riding on the stern of one of the first tugboats to sail to Cape Charles, around 1885. (Nut Redden collection; courtesy of CCHS.)

The Arlington Inn, also known as the Arlington Hotel, was opened in 1886 by Littleton H. Sturgis. The hotel was built on the corner of Mason Avenue and Pine Street on lots 642 and 643. In 1921, the hotel was moved 90 feet to the north on Pine Street to make room for the new Farmers and Merchants Trust Bank. These potato buyers posed for a photograph during Fourth of July celebrations in 1912. (Courtesy of CCHS.)

Cape Charles swarmed with activity during potato season. By 1900, Cape Charles was the main shipping point for potatoes grown on the Eastern Shore. The harbor became clogged with boats bringing crops to be shipped, and the streets were filled with farmers arriving via land with their potatoes. Mason Avenue and the Arlington Hotel are visible in the background of this photograph. (Courtesy of CCHS.)

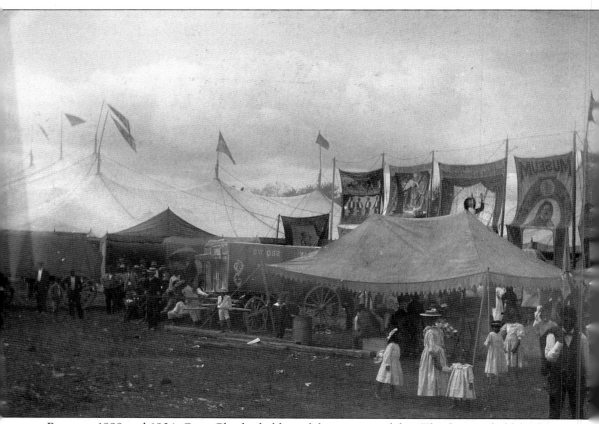

Between 1888 and 1904, Cape Charles held an elaborate annual fair. The fair was held for four days, Tuesday through Friday, during the last week of August, with one day set aside for African Americans to attend. The fairgrounds were located between Washington Avenue and the mouth of King's Creek, now the location of a Bay Creek community. Numerous vendors, rides, and games were available for the entertainment of fairgoers, but the main attraction was the half-mile racetrack on the fairgrounds. Hot air balloon rides were a popular attraction as well. The fair also hosted numerous agriculture-related competitions. Nellie Brickhouse of Bayview won first place in the apple pie competition in 1890, taking home a prize of 75¢. That same year, J. A. Jarvis of Eastville took home first place for coop chickens and a $1 prize. The fair was hugely popular in its first few years, but by 1900 attendance dropped, most likely due to competition from other fairs in the area. (Nut Redden collection; courtesy of CCHS.)

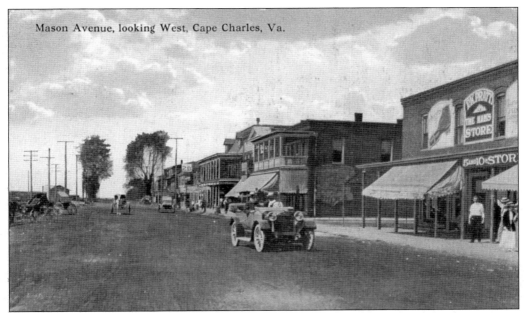

Mason Avenue, looking West, Cape Charles, Va.

As Henry Ford's Model T carried the nation into the age of the automobile, Cape Charles was not left out of the excitement. Shown here is an early Model T cruising down Mason Avenue around 1915. By this time, Mason Avenue had become quite developed with storefronts, as railroad traffic increased dramatically. (Courtesy of CCHS.)

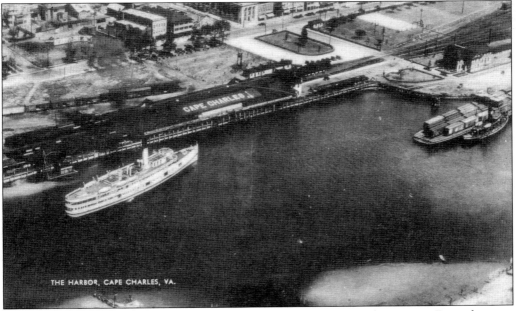

THE HARBOR, CAPE CHARLES, VA.

By the 1920s, Cape Charles harbor was a large and busy port. Here the steamer *Pennsylvania* is pulling into the docks to transfer passengers. The barge on the right is loaded with freight cars, with its tug moored alongside. Mason Avenue, with the new bank building, is visible at the top edge of the photograph. (Courtesy of Dave Scanlan.)

This sturdy-looking Farmers and Merchants Trust Bank building opened for business on June 7, 1922. Built on the corner of Mason Avenue and Pine Street, the bank displaced the Arlington Hotel, which was moved 90 feet north to make space. The bank's structure is made of stone, brick, and concrete, with Indiana limestone used on the exterior. The construction costs were approximately $150,000—a fairly substantial amount of money during that time. Farmers and Merchants Trust Bank was founded in Cape Charles by William Wilson, a prominent businessman in the community. He was involved in opening the Cape Charles Ice and Lumber Company, as well as running a large department store on the northwest corner of Mason Avenue and Strawberry Street. The bank building remains today, as a Bank of America branch. (Courtesy of CCHS.)

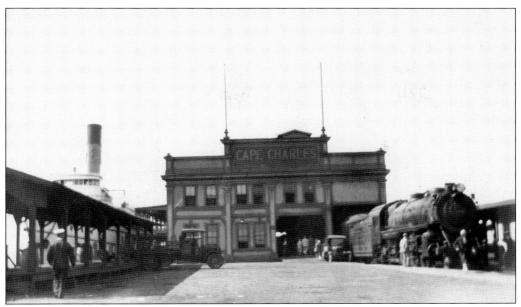

This photograph, likely taken in the early 1920s, shows the east end of the passenger and freight station. Steamships docked on the left side in the deep harbor. This building marked the official southern end of the railroad on the Eastern Shore, as passengers and cargo made the transition from rail travel to boat and vice versa. (Courtesy of CCHS.)

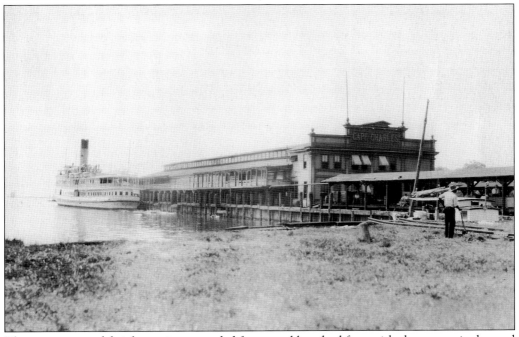

The passenger and freight station extended for several hundred feet, with the cargo pier beyond the station. The pier and harbor buzzed with activity, especially during potato harvest season. In 1923, two years before this photograph was taken, a total of 259,053 freight cars were transported across the bay during the course of the year. (Nut Redden collection; courtesy of CCHS.)

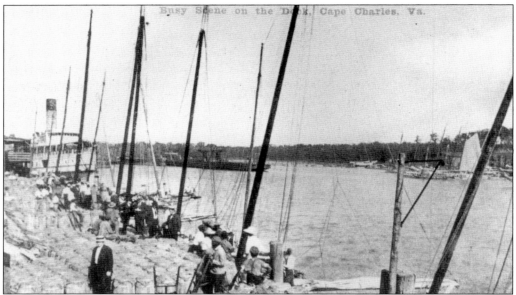

Barrels are lined up on the Cape Charles pier awaiting shipment. These barrels, likely full of potatoes, came from area farms, brought to the pier by the sailboats docked alongside. The barrels were loaded onto freight cars and then shipped north. Potatoes came from as far as Nandua Creek to be shipped, and local watermen sometimes made extra money by transporting potatoes to Cape Charles aboard their fishing boats. (Courtesy of authors.)

In December 1885, the customhouse was moved from the county seat in Eastville to the bustling new city of Cape Charles. It was located in the Times Office Building, where the *Northampton Times* was printed and published. The building was on the northeast corner of Randolph Avenue and Strawberry Street. (Courtesy of Carl Bundick.)

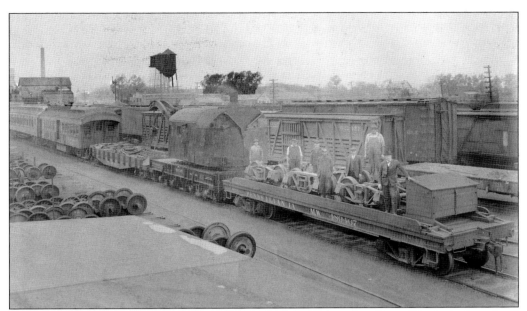

Part of the wreck crew posed for this photograph at the rail yard in Cape Charles in late April 1924. The men on the flat car are, from left to right, Jim Somers, Oscar Scott, unidentified, Jim Baker, Herman Moog, Sam Miles, and C. G. Brown. The man leaning out of the cab is John W. Shaw. The sets of wheels on the left are replacements for cars with defective wheels. (Nut Redden collection; courtesy of CCHS.)

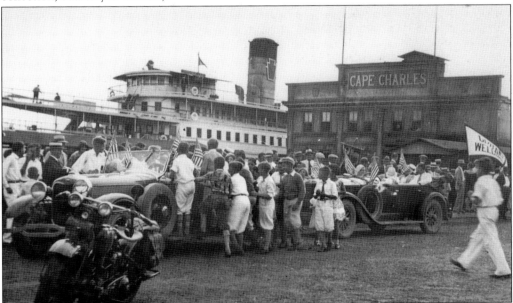

A crowd of people welcomed a large business delegation led by Gov. John Pollard on September 11, 1930. Pollard and 400 businessmen traveled to Cape Charles to encourage economic growth through the use of the railroad infrastructure. A mock burial was held for "Old Man Business Depression, his wife Mrs. Pessimism, and his daughter Miss Misfortune." Despite the governor's efforts, the Depression had a large impact on Cape Charles. (Courtesy of CCHS.)

Mason Avenue and the harbor developed considerably during the 1920s, as seen in this photograph from around 1925. While many people still used horse and buggy for transportation, many automobiles can be seen lining the busy streets. Cape Charles was a busy town of commerce, but residents still found time for recreation, as evidenced by the tennis court to the left of Mason

Avenue. This photograph captured Cape Charles in its heyday. By 1920, the town's population had passed 2,500—more than doubling since 1910—but once the Depression hit, the town's population struggled to reach the same levels it had during the Roaring Twenties. (Courtesy of CCHS.)

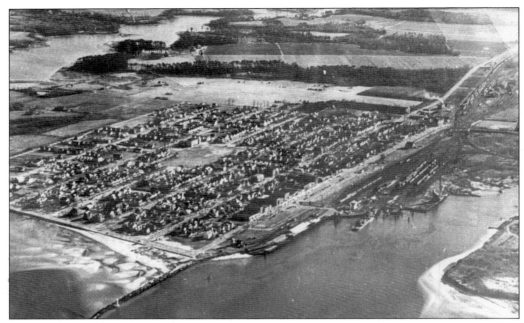

This aerial photograph of Cape Charles, taken sometime during the 1950s, shows a fully developed town with the grid of streets and avenues clearly distinguishable. By the 1950s, however, the railroad was suffering. Steamer service ended in 1953, while passenger train service stopped in 1958. Freight operations continue to this day. (Robert J. Lewis collection; courtesy of CCHS.)

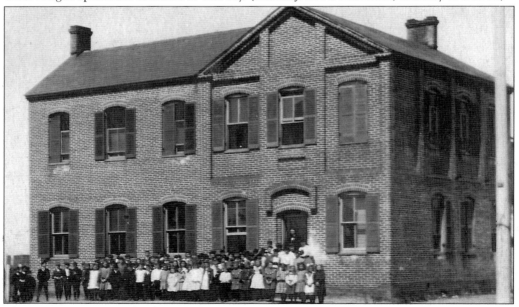

The Monroe Avenue school was built in 1893 to replace the Tazewell Avenue school, the first public school in Cape Charles. When it opened, the school had an enrollment of 67, with two teachers, but by 1906 enrollment swelled to 100, necessitating additions to the school. The first class to graduate from high school on the Eastern Shore graduated from this school in 1901. (Courtesy of CCHS.)

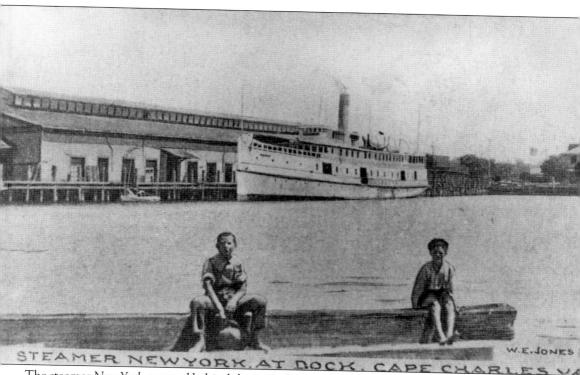

STEAMER NEW YORK AT DOCK. CAPE CHARLES VA

W.E.JONES

The steamer *New York*, moored behind these two boys at the Cape Charles pier, was built in 1889 for the NYP&N. The vessel, built by Harlan and Hollingsworth in Delaware, was 207 feet long and 31 feet in breadth. She carried a crew of 25. The *New York* provided regular service across the bay, between Norfolk and Cape Charles, during 1889 and 1907. After 1907, it became a relief boat for regular steamers under repair. In 1910, the *New York* was heavily damaged by fire while moored in Norfolk and again in 1932 while in Staten Island, New York. It was converted to barge use afterwards and was finally abandoned in 1941 after a hard life. (Courtesy of authors.)

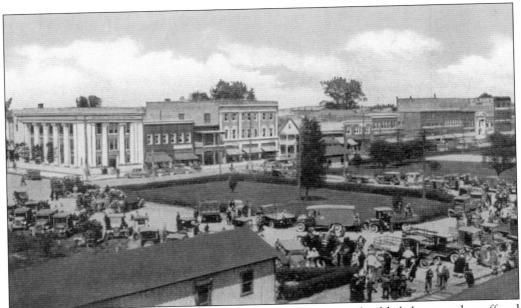

Postcards depicting busy scenes on Mason Avenue were very popular, likely because they offered accurate representations of what everyday life was like in the commercial center of Northampton County. As with most postcards during those times, this was a black and white photograph that was likely hand painted with color. (Courtesy of CCHS.)

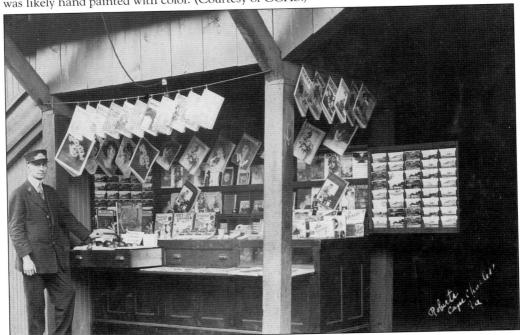

The Union News Company had newsstands in rail stations all across the country selling magazines, newspapers, and postcards to travelers. Pictured here is the newsstand at Cape Charles around 1925. Some of the postcards sold at this stand may now be part of local collections or even reprinted in this book. (Courtesy of CCHS.)

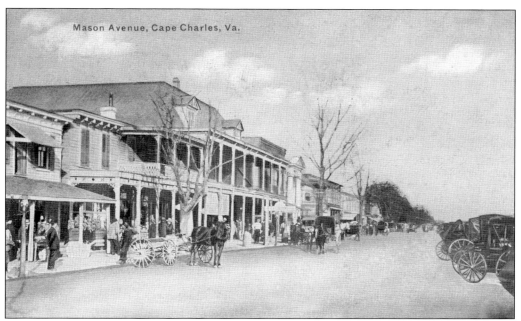

Mason Avenue, Cape Charles, Va.

This view is of Mason Avenue, looking east, from around 1898. The streets were still unpaved at that time, but streetlamps had been placed along the sidewalk. The store on the left appears to be a grocer's, with produce displayed under the awning. (Courtesy of CCHS.)

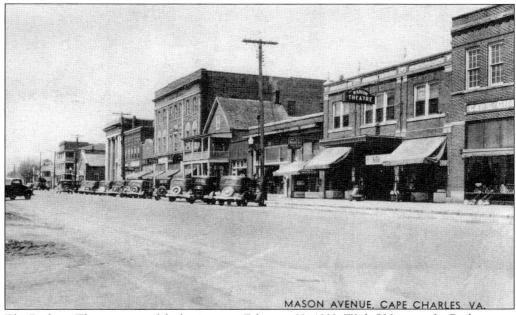

MASON AVENUE, CAPE CHARLES, VA.

The Radium Theatre opened for business on February 22, 1922. With 500 seats, the Radium was the largest theater on the Eastern Shore of Virginia at that time. Admission to see a movie was 25¢, and a different movie was played every night of the week except for Sunday. During each World Series, the Radium had an electronic scoreboard that was updated in real time so fans could follow the games as they occurred. (Courtesy of Dave Scanlan.)

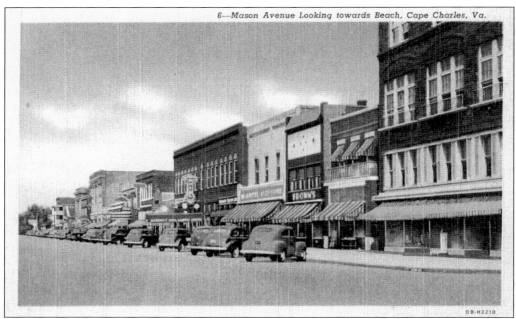

This postcard, from around 1940, shows the many storefronts and businesses along Mason Avenue. Brown's was a popular clothing and department store, first opened in 1899 by Will Brown. McCarthy's Hotel and Coffee Shop was just down the street from Brown's. McCarthy's was built in 1884 and operated as a hotel for decades. It was recently renovated and is once again providing rooms for guests. (Courtesy of CCHS.)

Charley Malar, on the left, tends the garden at the Cape Charles Commissary in 1924. The garden was just north of the main line. The Farmers and Merchants Trust Bank is visible in the background. C. E. Bounds is standing on the right side of the photograph. (Nut Redden collection; courtesy of CCHS.)

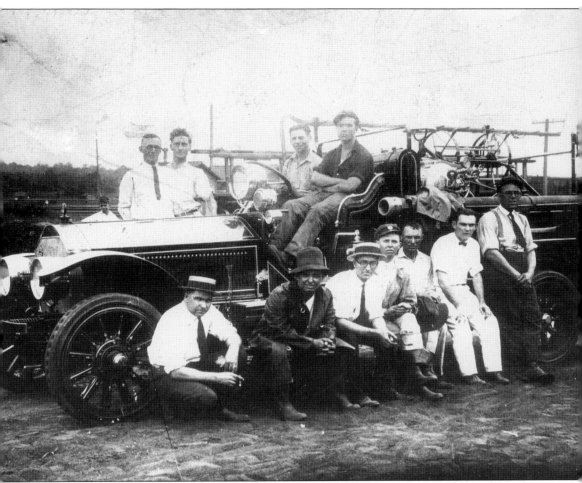

The Cape Charles Volunteer Fire Department posed with their new truck in this photograph from around 1924. For several years, the town went without an organized fire company. There was a group of nine men as early as 1885 who fought fires, but they were ill-equipped and disorganized. Because there was no firehouse in town, the meager equipment was spread around town in small tin sheds. The fire company did not officially organize until 1889, and the first firehouse was built in 1905. By 1923, the Cape Charles Fire Company had expanded to 24 members. On March 6, 1924, all 24 of those members were needed to fight the most destructive fire in the town's history. Eight buildings along Mason Avenue were destroyed, with total estimated damage to be $100,000. After the fire, the department ordered its first fire engine, an American LaFrance 750 gallon pumper that cost $12,000. (Courtesy of CCHS.)

The NYP&N's commissary supplied all the steamers, tugs, and barges with food, linens, and dishes. Commissary officer C. E. Bounds, on the left, shows M. H. Lingenfelter the Smithfield hams waiting to be distributed. Lingenfelter later became the local railroad superintendent in June 1951 as passenger service was slowly discontinued. (Nut Redden collection; courtesy of CCHS.)

Here C. E. Bounds and Charley Malar work in the commissary office in May 1927. While passenger traffic was heavy during the 1920s, it surged during World War II. In 1944, more than 1.1 million passengers were transported across the bay by steamers *Elisha Lee* and *Maryland*, certainly keeping the commissary busy supplying food to the ships. (Nut Redden collection; courtesy of CCHS.)

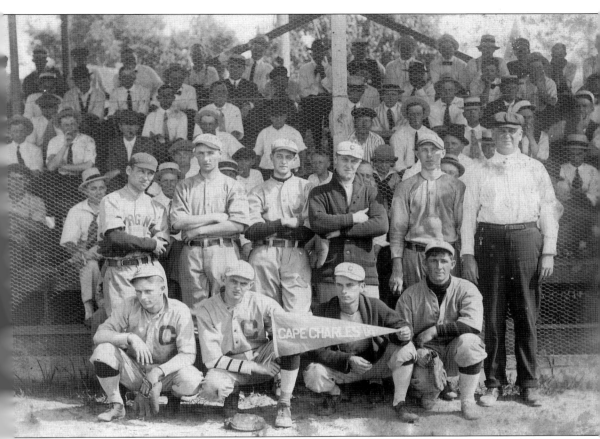

Baseball was by far the most popular sport in Cape Charles, as well as the country, during the early 20th century. The railroad organized a semiprofessional league in the early 1900s, providing a great source of entertainment and pride for citizens in the area. Four teams were formed: one team represented the Delaware Division, one represented the Baltimore Division, and two represented the Norfolk Division. Pictured here is the Cape Charles team around 1920, which played as one of the Norfolk Division teams. Team players were required to be from the immediate area but were not required to be railroad workers. Patton Field, where this photograph was taken, was home for the Cape Charles team. (Courtesy of CCHS.)

Modern times were not kind to the railroad on the Eastern Shore. Traffic continuously declined during the years following World War II, and between 1958 and 1960 the large old shops built in 1910 were torn down. The condition of the line running up and down the Eastern Shore deteriorated greatly, and in 1976 Conrail assumed ownership of it. Conrail, or the Consolidated Rail Corporation, was a government-backed creation of Congress to keep railroads from being abandoned once their parent companies became insolvent. Conrail turned the line over to the Virginia and Maryland Railroad on April 1, 1977. The men in this photograph were the last crew working at Cape Charles before Conrail left on March 31. Seated at the desk is Howard Brooks, a clerk. The men standing are, from left to right, M. K. Vandegrift, engineman; Billy Wilkins, clerk; Charlie Booker, yard master; G. Wilson, conductor; Harry Wooldridge, conductor; and J. H. Higby, brakeman. (Courtesy of CCHS.)

Cape Charles High School was well-known for its athletic teams' prowess. In 1950, the football team went undefeated; in the process, they soundly defeated Northampton High School 93-0. The team went undefeated again in 1955, winning the district championship. They also avoided any losses in 1919, though at the time the season consisted of only three games. The 1968 team, shown here, was one of the first integrated teams on the Eastern Shore of Virginia. (Courtesy of CCHS.)

Homecoming queen Peggy Lynne Horsley and king David Dix took a ride on the royalty float during Cape Charles High School's 1963 homecoming. Cape Charles retained its own high school, separate from the county's school system, until 1987 when a federal judge ordered it to be consolidated with the county. Elementary grades were taught in town until 1993. (Courtesy of CCHS.)

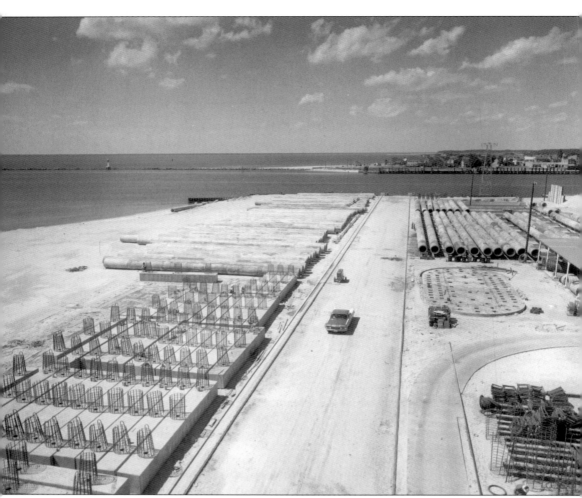

Located on the south side of the harbor, Bayshore Concrete has been a large employer in Cape Charles since it opened in 1961. The company was hired to make the pilings and other concrete structures for the construction of the Chesapeake Bay Bridge-Tunnel. In order to fulfill the massive order, including more than 2,500 pilings, a $3.5 million plant was built. The new business employed roughly 100 people. The plant began producing immediately, as illustrated by this photograph taken only a few months after the plant opened. Already the huge pilings were lined up, ready to be hauled to the construction site. In the foreground are bent caps, which were placed on top of the pilings after they had been driven into the bottom of the Chesapeake. Bayshore Concrete remains in business today as a subsidiary of Skanska USA Building, Inc. (Courtesy of CBB-T.)

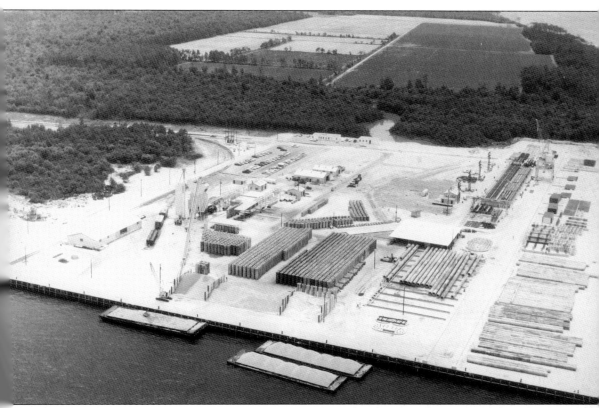

While the pilings in the middle of the plant look short from this distance, they were in fact 16 feet long. These shorter pilings were then attached to the bottom of the larger pilings and driven into the bottom to provide secure support for the trestle roadway. In a bit of cruel irony, the building of the Chesapeake Bay Bridge-Tunnel put the finishing touches on Cape Charles's economic decline. Passengers no longer traveled through the town on their way to the big cities and most freight was hauled by truck. In time, however, the bridge eventually allowed affluent residents of Hampton Roads and other cities to explore and fall in love with Cape Charles's quiet, tree-lined streets, stately Victorian homes, and the newly built, award-winning golf courses at Bay Creek that are bringing in a new era of prosperity for the town. (Courtesy of CBB-T.)

www.arcadiapublishing.com

Discover books about the town where you grew up, the cities where your friends and families live, the town where your parents met, or even that retirement spot you've been dreaming about. Our Web site provides history lovers with exclusive deals, advanced notification about new titles, e-mail alerts of author events, and much more.

MADE IN THE USA

Arcadia Publishing, the leading local history publisher in the United States, is committed to making history accessible and meaningful through publishing books that celebrate and preserve the heritage of America's people and places. Consistent with our mission to preserve history on a local level, this book was printed in South Carolina on American-made paper and manufactured entirely in the United States.

This book carries the accredited Forest Stewardship Council (FSC) label and is printed on 100 percent FSC-certified paper. Products carrying the FSC label are independently certified to assure consumers that they come from forests that are managed to meet the social, economic, and ecological needs of present and future generations.

FSC
Mixed Sources
Product group from well-managed forests and other controlled sources

Cert no. SW-COC-001530
www.fsc.org
© 1996 Forest Stewardship Council

Find Your Place in History.